Kiawah Island

February 22, 2008 EIGHTIETH BIRTHDAY OF:

James Quash Stevens Jr.

Great-Grandson of Quash Stevens " Cassique of Kiawah".

Celebrating his birthday with Jim were:

Quash"s Great-Great Grandchildren:

James Quash Stevens III

Jeffrey William Stevens

Gabrielle Lyn Stevens Holder

And Great-Great -Great -Grand children:

James Quash Stevens IV

Pilar Soleil Ela Holder

Sloane Paloma Holder

AND SPECIAL FAMILY AND F

D1089217

Kiawah Island

A HISTORY

ASHTON COBB

Charleston · London

History
PRESS

Published by The History Press
Charleston, SC 29403
www.historypress.net

Cover Image: Palmetto Hammock by William McCullough.

First published 2006
Second printing 2006
Third printing 2007

Manufactured in the United Kingdom

ISBN 978.1.59629.039.6

Library of Congress Cataloging-in-Publication Data

Cobb, Ashton.
Kiawah Island : a history / Ashton Cobb.
p. cm.
Includes bibliographical references.
ISBN 1-59629-039-0 (alk. paper)
1. Kiawah Island (S.C.)--History. I. Title.
F277.B3C63 2006
975.7'91--dc22

 2006013246

"The world is forgetting, and by the world forgot," seems to be the motto for this Island. It is certainly a lovely spot, where nature has lavished his best, which man has placed clear out of mind.
—Julia Blake, describing Kiawah Island, April 24, 1900

CONTENTS

ACKNOWLEDGEMENTS

While writing this book I have accumulated obligations to a host of friends, professors and museum professionals who have offered insight, advice, expertise and an indulgent ear. Professors Max Edelson, Bernard Powers and Bo Moore supplied their vast knowledge and enthusiasm for history. I would like to thank my family, particularly my father, always there to listen about "the Kiawah book" and to offer his recollections. Dennison Royal graciously gave of his time to talk about his family's key role in the development of the island. Barbara Winslow was a tremendous help, always promptly answering my e-mail inquiries and providing me with sound answers and advice. I would also like to thank Jason Chasteen at The History Press for his patience and his belief in the project.

I would also like to thank the staffs of the Charleston Museum, Historic Charleston Foundation and the Gibbes Museum of Art for their assistance in locating images for the book. Bryan Collars at the South Carolina Department of Archives and History did a great job preparing the plats for publication. Lastly, the staff at the South Carolina Historical Society was great. I want to thank Dr. Eric Emerson and Mike Coker for their generosity and expertise. My warm thanks to all who have helped directly or indirectly with this project. You have made this a very rewarding experience.

INTRODUCTION
AN ISLAND IN TIME

This book is an attempt to tell the history of a small place in coastal South Carolina. Historians write about the past using written sources. Newspapers and government records are very helpful, but when someone's personal papers survive, that is truly a small miracle. As the reader will shortly discover, sources about the history of Kiawah, particularly its early history, are quite scarce. Historians have asserted that certain places on the South Carolina coast have no history. Just because the written sources are obscure does not mean that these islands played no part in the development of the state or region. But this book was completely a labor of love for me, so I dug earnestly in many libraries to discover the history of one of the most beautiful islands on the Atlantic seaboard.

Marc Bloch, the great French historian, once wrote, "The migration of manuscripts is, in itself, an extremely interesting object of study." The earliest surviving manuscript relating to Kiawah Island is an indenture dated January 4, 1723. It is an agreement between two planters, John Stanyarne and Jonathon Drake, and it has to do with the purchase of livestock on the island. Stanyarne's granddaughter, Elizabeth Raven, married Arnoldus Vanderhorst in the late 1760s and she inherited half of the island upon her grandfather's death in 1772. Apparently, the Vanderhorsts acquired Stanyarne's Kiawah plantation papers, because that early indenture is to be found among their papers today at the South Carolina Historical Society in downtown Charleston. Outside of colonial land and legal records, that document is the only scrap of evidence about John Stanyarne's plantations that survives today.

The last male Vanderhorst to live in the South Carolina Lowcountry was Arnoldus Vanderhorst V, and he died unmarried on December 21, 1943. A year or so after his death, Adele Vanderhorst Ravenel, his eldest sister, donated the family papers to the

South Carolina Historical Society. Filled with references to Kiawah Island, the collection is essential to anyone interested in the island's past. However, piecing together the lives of the African Americans who lived on Kiawah as slaves or farmers is virtually impossible. In this case, the elites are writing the sources. Obviously, the Vanderhorsts asked different questions about Kiawah's past than historians of the early twenty-first century do. Elias Vanderhorst once remarked to his brother, "I have enjoyed the additions to the Kiawah picture, namely that of Ann Vanderhorst [his grandmother] and Mother's." If a historian is interested in agriculture, slave life or environmental change, he must work harder with the sources. For the Vanderhorsts, Kiawah represented family.

The Vanderhorst papers are very helpful in studying Kiawah's history, but even the Vanderhorsts did not save everything. During the summer of 1932, Arnoldus Vanderhorst V sent his family articles he had written about the history of the various plantations his family had owned. None of those manuscripts survive. His brother Elias commented to him that "it would add greatly to the record if you included your impressions and experiences with the Island." If Arnoldus followed his brother's advice, there is no record of it. Elias signed off on the letter by stating, "I am afraid if you do not tackle it sometime in the future some far less competent person will." Well, Mr. Elias Vanderhorst, here goes.

My family has been associated with Kiawah Island since the 1950s. My great-grandmother, Margaret Burns Johnson, purchased a beachfront lot and house in 1955. She worked for C.C. Royal, the island's owner, at one of his lumber companies in Augusta, Georgia. Growing up, we often spent the summers on the island. I was inspired to write this book when I was young, bicycling around Kiawah Island. I remember seeing houses, condos and golf courses being built. One summer day, with my brother and cousin, we discovered the old Vanderhorst House. Back in the early 1980s, the house was in poor shape, and there was a chain-link fence around the old place. Yet the house definitely had a sense of time and place about it, and I wanted to know: who lived here? How old was this house? Obviously whoever owned the house had been wealthy; did they own slaves? Where did the slaves live?

John Leland wrote a short history of the island in the late 1970s, and it satisfied me. Clearly Kiawah Island had a history, but where were the books about it? I went to college and majored in history, checking the library looking for books or scholarly articles about Kiawah. The Chicora Foundation published their important work in 1993, and I was thrilled. The archaeologists researched the island fairly well, but they did not always interpret their findings.

The owners of Kiawah are a good case study for the behaviors, attitudes and practices of the South Carolina Lowcountry planter. When planters of the South Carolina Lowcountry attempted to carve profits from the land, their successes and failures were the consequences of their understanding of the physical environment. The Sea Islands of South Carolina became places where planters and slaves put great emphasis upon agricultural knowledge and innovation. While the unique natural environment of

Kiawah Island offered advantages to the planters who owned land there, the Sea Island agricultural landscape forced the planters to have flexible attitudes about their coastal lands. The Kiawah planters, like most of their counterparts in the Lowcountry, were constantly searching for the most efficient and lucrative ways in which to use their land. Planters like Stanyarne, Vanderhorst and Shoolbred experienced success planting on Kiawah, so these families began to think of the island as being a distinctive place. After the Civil War, the Vanderhorsts struggled to maintain their Kiawah plantation. The black workers on the island constantly looked for a crop that would sustain them. Tenant farming and the boom and bust cycle of the cotton market dominated life on the island until the 1920s. After cotton production ended, black families migrated off of the island, hoping to find a better way of life.

The modern world came to Kiawah in the early 1950s, when C.C. Royal bought the island. Royal brought the first modern conveniences to the island, as well as the first beach development. The Kuwaitis purchase of the island in the mid 1970s allowed Kiawah's world-renowned resort to be built. With a year-round population of about 1,200, the community of Kiawah Island looks to the twenty-first century knowing that many wealthy Americans will retire in the next ten years. Those baby boom retirees might put the island on a different course.

1.

THE PHYSICAL SETTING

South Carolina's Sea Islands were important economic and social indicators of landholding and economic activity for the rest of the state. A Charleston newspaper reporter, writing in the early 1880s, declared that "the lauded proprietors of the Sea Islands were…the wealthiest men in the State; they lived like barons, surrounded by their vassals, upon their estates, and by their wealth and social position wielded no small influence." This perspective followed almost two hundred years of economic and social development on the islands. Yet impressions about geography, topography and wealth are impressions about productive and economic capabilities. These perceptions change, as not all people at all times look to the land and water to yield the same things.

With the English came the market economy, which consisted of a series of economic activities concerning raw materials, landholding and cheap labor. These attitudes and activities tremendously altered life and landscape on the South Carolina coast. Staple crop agriculture became the source of great wealth in the Lowcountry, particularly on the Sea Islands. The topography and the climate of the islands were particularly suited for production of rice, cotton, indigo, provisional crops and cattle ranching. Raising cattle was ideal on the Sea Islands, as small bodies of land completely surrounded by water offered an effective boundary for livestock. The Sea Islands featured a longer growing season than the coastal plain or piedmont of South Carolina, permitting crops to be planted in March and harvested in September. The Sea Islands of South Carolina typified the colony's and, later, the state's dependence upon commercial agriculture.

Kiawah is a barrier island, located on the South Carolina coast twenty miles south of Charleston. The western point of the island borders Captain Sam's Inlet and Seabrook

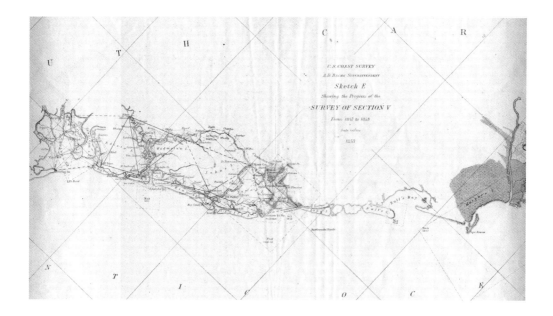

A view of coastal South Carolina, from the Coastal Survey drawn in the mid 1850s. *Courtesy of the South Carolina Department of Archives and History.*

Island. The eastern end of the island, called Sandy Point, stops at the confluence of the Stono River and the Atlantic Ocean. The Kiawah River divides the island from the mainland. Kiawah Island is a rare example of a depositional barrier island, rather than an erosional one. In other words, more sand is deposited on the island than is taken away by tides and surf. The island has a sand beachfront and is about nine miles in length and two miles in width, including both high ground and marsh. There are today approximately 3,300 acres of high ground and 3,730 acres of marsh incorporated into Kiawah Island, making it the second largest barrier island and the fifth largest island on the South Carolina coast. A resident of the island in the early 1860s observed that "the broad ocean washes the poor Island of Kiawah most cruelly, and perhaps will dip it right into the sea one of these days."

The temperate climate of Kiawah Island is directly controlled by oceanic factors. The annual Kiawah rainfall has been estimated at forty-nine inches per year. Peak rainfall occurs in July, with high amounts of rain during the other two summer months. The precipitation during the summer months is associated with intense, short-lived afternoon thunderstorms. Kiawah sees more annual rain than the cities of Charleston and Beaufort. Conversely, periods of drought can occur, causing damage to crops and livestock. Kiawah has been promoted as a "very fine winter climate, preferable in some respects to that of Florida, and the situation of this island on the sea makes its winter temperature on an average several degrees higher than the temperature in Charleston."

The average high temperature on Kiawah in July is eighty-one degrees Fahrenheit, although temperatures are frequently in the nineties during the middle of the summer. Kiawah normally experiences a high relative humidity, adding greatly to the discomfort of its human inhabitants. Researchers in the 1970s found an annual mean value of humidity of 73.5 percent, with the highest levels occurring during the summer months. Charleston merchant Robert Pringle noted of the Lowcountry in general that guns "suffered with the Rust by Lying so Long here, which affects any Kind of Iron Ware, much more in this Climate than in Europe."

Kiawah's annual growing season is 295 days, one of the longest in South Carolina. This fact was particularly important when the island featured indigo and cotton plantations. The high quality of the staples that grew on Kiawah might be attributed to the longer growing period that occurred on the island. The meteorological event most associated with the Sea Islands region is the tropical hurricane. Hurricanes occur in the late summer and early fall, the period critical to antebellum cotton production. The coastal area is a moderately high-risk zone for tropical storms, with approximately 180 hurricanes documented from 1686 to 2005. Kiawah's owners in the early twentieth century alleged that "the Island is not subject to overflow in case of storms, except the low portions of it."

Kiawah Island exhibits three major ecosystems: the maritime forest ecosystem, which consists of the upland forest areas of the island, the estuarine ecosystem of deep water tidal habitats, and the palustrine ecosystems, which consist of freshwater, non-tidal wetlands. The maritime forest ecosystem consists of five principal forest types: oak-pine forests, mixed oak-hardwood forests, palmetto forests, oak thickets and other miscellaneous wooded areas, such as salt marsh thickets and wax myrtle thickets. Of these the oak-pine forests are the most common, constituting over half of the forests on Kiawah. Typically, these forests are dominated by the laurel oak and the loblolly pine. Hickory is present, although uncommon. Other trees found are the sweet gum and magnolia, with sassafras and wax myrtle found in the understory. The understory is the group of bushes and thickets that are well below the tree line, often serving to feed and shelter animals. In the mixed oak-hardwood forests pine is reduced in importance and the laurel oak is replaced by the live oak. The palmetto forests are characterized by palmetto stands, with an understory of wax myrtle and red cedar. The low oak woods or thickets are found as a band behind the outer dunes of the beach. Finally, the miscellaneous wooded areas include wax myrtle thickets found in low areas near the dunes.

Kiawah's forests offered many uses for its lumber for the settlers who lived on the island. The loblolly pine was called the "pitch pine" and was used to produce tar and turpentine. Live oaks were recognized as yielding "the best of timber for shipbuilding." The oak and hickory high lands were well suited for corn and provisions, also for indigo and cotton.

The estuarine ecosystem on Kiawah Island includes areas of deepwater tidal habitats and adjacent tidal wetlands. Estuarine systems are influenced by ocean tides, precipitation,

freshwater runoff from the upland areas, evaporation and winds. The mean tidal range for Kiawah is slightly over five feet, indicative of an area swept by moderately strong tidal currents. Strong, tall grasses grow in this area, as well as a very large and diverse animal population. Many birds, shellfish and small mammals feed and live in these marshes.

The freshwater ecosystem includes all wetland ecosystems, such as the swamps, bays and creeks where water salinity is very low. These ecosystems tend to be diverse, but they have not been studied in great detail. Most of Kiawah's freshwater environments appear to have been created during the twentieth century, primarily unintentionally by the creation of dikes to support logging roads.

On Kiawah Island, drinking water appears to be plentiful, yet sources of fresh water are scarce. The fresh water supply was a very important determinate of economic activity on the island. The two main staple crops of the eighteenth century, rice and indigo, both required a reliable water supply. According to an observer, rice "is a grain which yields the most plentiful harvest when the ground is overflowed with water." The source of the water could not be the sea or the marshes, as salt water killed crops. Indigo also required a fresh water supply. The plant did not need to actually grow in water, so the planter could dig a few wells to furnish a supply. Water was also necessary to process the indigo from a leaf to a dye.

There are six types of soil on Kiawah Island: Crevassee-Dawhoo, Dawhoo-Rutledge, Kiawah, Rutledge-Pamlico, Seabrook and Wando. Of these soils, only two (Seabrook and Wando) are considered well drained. The remainders are poorly drained, except for the Crevassee-Dawhoo soils, found in the ridge and trough area at the eastern part of the island. These soils have mixed drainage. Only about a quarter of the island can be considered to be well drained. The western and central thirds of the island consist primarily of Wando soils ringing the edge, while Kiawah and Dawhoo-Rutledge soils are found on the interior. The eastern third of the island contains little well drained soil, being composed largely of Crevassee-Dawhoo soils. Kiawah's owner once described the island as not being a "sand-bank as are some of the Sea-Islands along this coast, but [the island features] good stiff soil heavily wooded with oak, cedar, and luxuriant palmetto."

Soil drainage may reasonably be expected to have had an impact on settlement patterns on Kiawah Island as well as cultivation, and in turn, plantation wealth. Plants such as indigo and sea-island cotton required well-drained soils. While a large portion of the land on Kiawah appeared to be unsuitable for most crops, it was clear to planters that adequate drainage could be constructed to make the soils more agriculturally productive.

Besides a few exploratory voyages and a few shipwrecks, no Europeans had investigated the opportunity that the Carolina Sea Islands offered before the early sixteenth century. Most Spanish, French and English sailors were hesitant to leave the safety of their ships to explore the land the Spanish called Santa Elena. The Spanish sailor Pedro Menendez Marques entered "the harbor of Cayagua" in August 1586, "and lay there three days

trading maize and food." The place name "Cayagua" would have a different spelling, Kiawah, when heard by English adventurers. In 1666, Englishman Robert Sandford was anchored in the South Edisto River when several Amerindians came aboard his vessel. According to Sandford, one of them "is knowne by the name of Cassique, hee belongeth to the Country of Kiwaha." On the eve of the first successful English settlement of Carolina, the region of Kiawah was north of Port Royal, south of Charles Town in Clarendon, but full of uncertainty. Apparently the Kiawah chief was seeking protection from the Westo Indians who had recently raided his tribe. For the settlers, security was clearly the main reason to choose the Ashley River site. The settlement was located on high ground on the western side of the river, several miles from the mouth. The settlers kept close together at first, building strong huts and a high palisade around the town. Their fears were justified when, in August 1676, three Spanish warships, with Indian allies, attacked the English town. A storm forced the belligerent force to withdraw.

It is not difficult to imagine what the Carolina Sea Islands looked like when the English established their successful colony at Charles Towne in 1670. Robert Sandford's account depicted a landscape of rivers, marshes, fields of corn and Amerindians bartering for European goods. Almost a hundred years later, a visitor to Kiawah Island recorded his impressions of the landscape. His description started poetically, "This place is not an Elysium, nor is it equal to the Garden of Hesperides; it however affords some delights, and exhibits scenes, tho' rude, happily calculated for phylosophic solitude and contemplation." The visitor continued, "The face of the Country is flatt, and the soil rich; the air is salubrious, and rendered exceedingly soft by the salt vapour that rises from the sea. A variety of small Oaks, tall Palmeto's, and little shrubs extend in thick confusion from one end of the Island to the other." The visitor also noted the bodies of water that surround Kiawah, noting that the "Island is divided from the main Land by a river on the North, and lashed with the most inveterate by the Atlantic Ocean on the south. At low Water it exhibits, perhaps, the finest beach in the World." To an American soldier in the last year of the Revolution, the Kiawah Island landscape appeared healthy and rustic.

The landscape itself and, especially, the perception of the Sea Island landscape by English colonists affected settlement and landholding practices in the early colonial period. By the middle of the eighteenth century, when planters produced staple crops successfully on Kiawah, the environment played a role in the quality of the commodity. The Revolutionary War caused Sea Island planters to change their economic practices, and, in turn, forced them to choose another staple crop that was particularly suited to the Sea Island landscape. The planters of the Sea Islands knew very well that they must maintain a dialogue with the landscape in order to keep their economic and social status. The Sea Islands posed unique problems for planters and their slaves. This book reveals those struggles.

2.
MANY KIAWAHS
1670–1720

The economy of early South Carolina, from 1670 until about 1700, revolved around goods that the colonists shipped to the Caribbean or back to England. The production of provisions, deerskins and naval stores did not require much labor or much initial capital investment. These land-intensive activities gradually gave way to economic ventures requiring greater inputs of labor and capital. None of these early ventures were lucrative, and the relatively few who prospered appear to have done so mainly by the aggressive and simultaneous pursuit of various opportunities. The English settlers' perceptions of the land itself changed as Carolinians found new commodities to produce. The Lords Proprietors granted Kiawah Island to Captain George Raynor in 1699, just as the colony found a valuable commodity to produce: rice. The colonists perceived the outlying Sea Islands as unpromising for settlement since rice could not be grown on a large scale in places that were surrounded by saltwater. In spite of this disadvantage, Raynor attempted to bring Kiawah Island into the market economy with his aggressive economic behavior and his willingness to diversify his economic interests.

Yet another transition occurred in the colony of South Carolina in the late seventeenth century. Settlers had to continually reevaluate their perceptions of land and resources in the Carolina Lowcountry. The changing nature of the colony's economy was the prime impetus for the vacillating nature of the white settlers' attitudes about their natural environment. The name for the original English settlement on the Ashley River in 1670 was Kiawah, after the Indian tribe that lived adjacent to the site. A barrier island also acquired the name Kiawah in the 1690s, reflecting the changing perceptions not only of resources in South Carolina, but also about economic potential in the young colony.

By the time that the English arrived in 1670, the Indians had developed cultures well adapted to the landscape. They fished, hunted and gathered a rich variety of food, herbs and raw materials for clothing, weapons, shelter and tools from the marsh, island, river and mainland environments. They derived adequate sustenance from the land to allow for a surplus that made cultural development possible. The tribes of coastal South Carolina had developed complex levels of social and cultural integration, had a system of religious practices that regulated their behavior toward the natural world, and exchanged products of the coastal environment through far-reaching trade networks. The tribes of the Lowcountry included the St. Helena, Wimbahee, Combahee, Witcheau, Edisto, Stono, Kiawah, Wando, Ashepoo and Coosa.

Communication and trade were facilitated by the sharing of tobacco. Ritual guided most social behaviors in coastal Amerindian societies. Although not much evidence survives that would describe and explain the rituals and belief systems of the coastal South Carolina natives, it is clear that they, like other peoples of North America, had a sense of social obligation that extended beyond human beings and into the natural world. Animals, plants and water were not objects but beings, animate and powerful. Hunting, fishing and gathering involved a relationship with the other beings and forces in the world, and proper and continued success depended on rituals that would restore or maintain harmony with these other beings. Some rituals asked forgiveness or regulated the use of an animal or plant. Other rituals offered deference to the spirits of these beings or a relevant fertility spirit. These rituals were an important part of the way in which the coastal Amerindians related to their environment.

Rituals and other aspects of the Amerindian cultural life that strengthened their interactions with the environment were severely disrupted by the arrival of the Europeans and their cultural and biological baggage. Microorganisms transported by the Europeans caused epidemics that devastated the southeastern Indian population, particularly among the coastal tribes. Efforts by the English settlers to exploit and control both the inhabitants and their habitats put pressure on the Wando, Santee, Bohicket and Kiawah cultures and altered traditional ways of life. English settlement patterns reduced the production of foodstuffs, and the European powers began to capture the natives for the slave trade.

The cassique of Kiawah understood that the landscape would permanently change once the English settled in the region. He wanted the newcomers near his tribe so he could enjoy the new trading and defense advantages that the Europeans offered. The English "settlement at Kyawaw" was a small town on a low bluff next to the Ashley River. The town called Kiawah, not the island, was surrounded by a high palisade and ditch for defensive purposes. A short distance beyond the settlement stood a Kiawah Indian village. Not all of the English colonists at Kiawah agreed on what their role should be in English New World expansion, but most agreed on what was at stake: their lives, their economic futures and their success against other European powers. And ultimately, this initial English settlement on the Ashley River was to draw new, firmer boundaries

between English and Indian people, between English and Indian land, and between what it meant to be "English" and what it meant to be "Indian."

Yet the boundaries between European and Indian were not stable in early colonial South Carolina. The seventeenth-century Carolina Lowcountry was, after all, a frontier, at once a dividing line and a middle ground between many Indian and European cultures. Boundary setting, as frontier historians have pointed out, is "the very essence of frontier life." So the English colonists on the Ashley River in Carolina, beginning in 1670, began identifying and naming the physical landscape that they encountered. The origins of the names of geographical areas could explain how the early English colonists regarded the landscape. In South Carolina's early colonial period, three contending cultures, Amerindian, English and African, clashed over the resources of the Lowcountry. While many Indian names remain on the South Carolina landscape, the tribes themselves have disappeared.

The processes of European exploration and colonization cultivated language in particular ways. Land conflicts, cultural anxieties and unfamiliar terrain drove colonists to name and sometimes misname physical features. As historian Patricia Nelson Limerick has written, "The process of invasion, conquest, and colonization was the kind of activity that provoked shiftiness in verbal behavior." The "shiftiness" can be explained in European ideas about nature, God and human behavior, ideas that can be traced to the earliest New World encounters and to questions about the indigenous peoples of the New World. Words describing places, like "Kiawah," "Carolina" and "Ashley" are at the nexus of encounters between the English of the Old World and the Kiawah of the New. As the bishop of Avila proudly announced when presenting Queen Isabella of Spain with a grammar book in 1492, "Language is the perfect instrument of empire." At the beginning of the English conquest of Carolina, the original English settlement was named Kiawah, a name of Native American origin, appropriate for an unfamiliar terrain, a shaky settlement and the entrance to an unknown, vast frontier.

In the Fundamental Constitutions of 1669, the Lords Proprietors of Carolina revealed their vision of an agricultural society based upon land tenure. The Fundamental Constitutions divided the new colony into four counties, each 480,000 acres. Each county was to contain eight seigniories of 12,000 acres owned by the eight Proprietors, eight baronies of 12,000 acres granted to hereditary nobility, and four precincts to be planted by the common settlers. Thus, within the 750 square miles of each Carolina county, the proprietors would hold 96,000 acres, three noblemen would hold 96,000 acres, and the settlers would own 288,000 acres collectively. The aristocrats and Proprietors would each control one-fifth of the land in Carolina while freemen would hold the remaining three-fifths. Since land was the key to wealth for all classes, generous land allotments were important in attracting settlers to the new colony. The first settlers received larger headright grants than those who migrated later. Any settler who transported his family, servants or slaves could claim 100 acres for each adult and 70 acres for those under age sixteen. These allotments were in effect until 1679. The proprietary design of the colony

had little regard for the actual characteristics of the land. The headright system was one of the major accomplishments of the proprietary land policies. They created a landscape that incorporated an English view of property with their own social, economic, political and military plans hovering in the background. The Proprietors assumed that Carolina featured a prodigiously rich soil that would allow for the rapid development of a mature agricultural landscape like the one that took centuries to evolve in England. The goals of the Carolina Proprietors were designed by earnest men with real economic and military concerns who made every effort to put their ideals into practice. But these goals projected an ideal community onto a poorly perceived landscape. The disparity between the ideals of the Carolina Proprietors and the experiences of the settlers who went there became apparent soon after the first shipload of colonists arrived at Kiawah on the Ashley River. The desire for profit permeated the colonists' attitudes in early South Carolina.

For the first few years of the colony, the settlers struggled to support themselves. By June 1670, rations had been reduced to a pint of peas per day. While building a town and clearing land to grow provisions, early Carolinians remained in constant fear of the Spanish and the Indians. Some of the local Indians remained friendly with the English. One of the visitors to the settlement wrote, "The Indians that boarder on them being soe friendly…supplye them with deer, fish, and fowle in a great abundance as likewise assisting them to cleare and plant their land."

Growing food was only the first challenge that the tiny settlement faced. The colonists also experimented to find a commercial crop. Without a staple commodity, Carolinians had nothing to barter for their needs and no means of generating capital to apply against debts or to buy imported goods. The Proprietors encouraged and aided agricultural experimentation. The early records of the province and letters of settlers are strewn with references to ginger, silk, grapes, rice, indigo, tobacco, olives and many other plants. A commercially significant crop did not immediately emerge, though a few crops were successful in isolated patches. The process of elimination in itself was important in testing the land and climate of the Lowcountry. The search for a commodity took years longer than either the Proprietors or settlers had originally anticipated.

Tobacco, timber, naval stores and cattle were exported from the Carolina colony beginning in the 1670s. Trading with the Amerindians was an important part of the early commerce. It consisted of settlers exchanging European manufactured goods with the Indians for deerskins and furs. Constant skirmishes with the Indians over land rights, destruction of crops and stolen livestock provided excuses to capture the offending parties and to sell them as slaves. These relations primarily affected the tribes who lived closest to the English settlement on the Ashley River.

In the summer of 1671, the Indians that surrounded the English settlement at Kiawah were regarded as "friends" by the colonists. The tribe physically closest to the English, "where we now live," was the Kiawah. By the 1680s, the Carolina landscape had changed dramatically because of continued European occupation. The once friendly and powerful tribe had been drastically reduced in numbers through disease and warfare.

A promotional pamphlet, published in 1682, described the "Kiawahs, that dwell upon the skirts of Ashley River; they reckon themselves but forty Bowman." Estimating three non-combatants for every warrior, their population would have been about 160. The tribe had moved their settlements in the early 1680s from the banks of the Ashley River to the Sea Islands immediately south of Charleston. By 1685, the Kiawah tribe had fled as far as they could by occupying, at least temporarily, the island named Kiawah.

The settlement patterns of the seventeenth-century English colonists forced the Kiawah tribe to move to lands that were less valued by the European arrivals. The lands that European arrivals valued were near water, preferably rivers. The access to deep water and the use of waterways as the major mode of communication resulted in residences and plantations being clustered up and down the major rivers of the Lowcountry. The banks of the Ashley, Cooper, Santee, Stono and Wando Rivers contained the most continuously settled lands since the arrival of the English. The Sea Islands, however, offered more subtle challenges to the early European colonist. These islands were isolated by water and also were vulnerable to attack from seafaring vessels.

The Indians also posed a challenge to English colonists who wanted to settle on the Sea Islands. By the late 1680s, the Kiawah Indians had migrated to Kiawah Island. An expedition led by William Dunlop encountered the cassique of the Kiawah living on the leeward side of the island, on the banks of Kiawah Creek. The Dunlop expedition visited the island in April 1687, catching the Kiawahs in the midst of planting corn, peas and beans. Living and planting extensively on a barrier island was unusual for the Kiawahs. Before English colonization, the islands were only visited temporarily for hunting game.

The Kiawah tribe found living on the island difficult. As the tribe was used to migrating at least twice a year to hunt and fish, the cassique's hut on Kiawah Island probably did not represent the tribe's only settlement in the Lowcountry. The tribe had a few other mainland sites of settlement. By the late 1690s, the tribe had left Kiawah Island and moved, but precisely when is difficult to determine. The Thornton-Morden map, published about 1695, has "Kayawah" written across Kiawah Island. Under that label appeared "Indian settlemts." An act of the proprietary assembly in 1696 mentioned the Kiawah River, indicating colonists' interests in settling the sparsely settled Sea Islands south of Charles Towne.

There are patterns to the early English land grants in the islands around Kiawah. Most of the grants are for lands that border on one of three major rivers, the Bohicket, Stono, or Kiawah. The earliest recorded grant was to Captain William Davis in 1680, a five-hundred-acre tract at the junction of Abbapoola Creek and the Stono River. The island directly to the south of Kiawah Island, Seabrook, was granted in 1695 to Landgrave Joseph Blake, a proprietary official. Other families who would be prominent in the islands south of South Carolina's main port included the Stanyarnes, Hexts, Godfreys and Waights. All of these families received land grants on Johns or Wadmalaw Islands in the 1690s.

In February 1699, Captain George Raynor placed a warrant in the Carolina land office for a 2,700-acre island in Colleton County. The following year, the Proprietors

granted him Kiawah Island. A mariner, merchant and assemblyman, George Raynor had ties to the Caribbean. He sailed out of the notorious Caribbean pirate depot, Port Royal, Jamaica. Raynor was also a merchant in South Carolina, lending money and recovering debts for clients. He also had business dealings in New York and Pennsylvania, performing the same services for colonists in the mid-Atlantic. Raynor started a trend amongst the early landowners on Kiawah Island. They were intimately associated with the sea, and they tended to be tough, hardened men who could defend themselves. They also were officials of the proprietary government. In 1701, Captain Raynor sold half of Kiawah Island to Captain William Davis. Davis served in the assembly with Raynor. The two men held 1,350-acre lots on the island. The size of the holdings is significant, as large holdings signify the desire to have economic activities that require a lot of land.

It is not possible to ascertain exactly why George Raynor wanted to own Kiawah Island. There are many possible scenarios. Raynor was intimately associated with the burgeoning merchant class in Charles Towne in the 1690s. In the middle of the decade, two merchants repaid Raynor a loan of 103 pounds. "Merchant" originally meant any trader in goods, but by the middle of the eighteenth century its original meaning had narrowed. Dictionaries, like the one written by Samuel Johnson, defined the merchant as one who "trafficks to remote countries." English trade experts described a merchant as one who moves in the "Way of Commerce" by "Importation or Exportation," who "makes it his living to buy and sell." The merchant began to be seen as a trader who dealt with foreign goods and countries. David Hancock studies eighteenth century English merchants as "associates," men who dealt in goods all over the world.

To Hancock, these merchants possessed two main characteristics: they constantly tried to improve their wealth as well as their position in society. The English merchants also practiced integration, which was linking the parts of the British Empire together in commercial and scientific ways. These men integrated their businesses geographically, combining goods from Asia, Africa, North America and Europe, while also managing multiple activities, like planting and shipping.

In the spring of 1700, William Penn wrote to the Commissioners of Trade about the development of the colony of South Carolina. Penn called Carolina a resort of suspected pirates associated with the legendary Captain Kidd. Penn mentioned George Raynor by name. Penn observed that the pirates had ceased the life at sea, and now "followed a life of husbandry, turning planters." Raynor may have used his lands in South Carolina as a way to diversify his business. While already in possession of a least one ship and some credit, he may have used Kiawah Island as a range for his cattle. Perhaps Raynor tried to move from Atlantic commerce to planting. Kiawah Island would be well positioned in this effort, as it was on the coast and close to Charles Towne. The imperial wars of the early eighteenth century pressured privateers like Raynor to settle in more legitimate business activities in order to provide the Atlantic world with a bit of economic stability. Daniel Vickers, writing about the fishermen of the Massachusetts coast, says that the early eighteenth century was a period when mariners began to settle on shore. Raynor

could have wanted to acquire land in South Carolina so he could retire from the sea and devote his time to his family and a new career on land.

Both Raynor and Davis died a few years later. Raynor's half of Kiawah went to his daughter, while Davis's half was sold to Richard Peterson, a seaman. Mary Raynor married Roger Moore, giving Moore ownership to half of Kiawah Island. Under South Carolina law, a married woman could not own property. Her husband could spend her money or sell her livestock or slaves. He gained managerial rights to her lands and controlled the rents and profits from all of her real estate. However, women held one note of power: no husband could sell real property or land without the consent of his wife. Moore may have violated this statute. In 1717, John Stanyarne bought the Moore half of Kiawah. Roger Moore's son, George, cleared the title to the property in the early 1740s.

In March 1743, the remaining Kiawah Indians had a meeting with colonial officials. The tribe, numbering about fifteen, requested a settlement to be put aside for them, "South of the Combee River." While no grant survived, it was possible that the Royal Council granted the tribe a small reservation. Like the original settlement and the island named for them, the Kiawahs became a part of the market economy that dominated colonial South Carolina. Unlike the places or the economy, the tribe did not last until the American Revolution.

The original English settlement at Kiawah did not survive either. Across the Ashley River was the tip of a peninsula dividing the Ashley from the Cooper River. The early colonists called this place Oyster Point. By the late 1670s, settlers built houses and fortifications there. In December 1679 the Proprietors moved their settlement to "Oyster Point [which is] a more convenient place to build a towne on than that…pitched on by the first settlers." Therefore, "Oyster Point is the place wee doe appoint for the port towne…which you are to call Charles Towne."

The name Kiawah still applied to the original settlement and to the river that the English lived adjacent to. In the 1690s, another river and a Sea Island also began to acquire the same name. In 1695, an act of the assembly mentioned the "Kiawaugh" river, which is the river that separated Kiawah Island from the mainland. The migration of the name indicated the movement of the Kiawah tribe, but it also may have indicated the movement of English settlements and the changing English attitudes about desirable land in South Carolina.

Most of the Sea Islands that surround Kiawah have names that derive from English: Johns, James, Seabrook (originally Jones) and Folly Islands. Other islands have Amerindian-based names, like Edisto and Wadmalaw. Another culture was involved in the shaping of the Sea Islands, and this culture also supplied place names to the region. On the western end of Kiawah Island, a sliver of high ground in the midst of salt marsh was called Mingo Point. When or how the name was placed on the area is unknown, as the 1803 plat of the island is the earliest source. The word "Mingo" is probably of

African origin, often used as a male's first name. The African meanings of the word are obscure. The presence of this place name on Kiawah revealed the competition of three cultures on the South Carolina Sea Islands.

By 1700, thirty years after the English settled Charles Towne, the Indian tribes native to the Lowcountry had begun to die out. The English began to expand their settlements and seek out land for cattle, provisions and a few staples. In establishing an agriculturally based society, cheap, ready labor was needed, often supplied by African slaves. This process had come to the Sea Islands south of Charles Towne. George Raynor was the first planter to experiment with the landscape of Kiawah Island. Other planter personalities would become attracted to the island as the colonial South Carolina economy developed.

The settlers who created and developed the new societies of colonial British America sought not only wealth and independence but also the goal of improved societies that would enable them to enjoy the prosperity of the new colonies. Writers who promoted South Carolina in tracts and treatises appealed to prospective settlers by emphasizing the abundance, safety and independence of the colony. The promoters also argued that South Carolina was a landscape and a society that was becoming more cultivated and improved. Ubiquitous in the economic writings of early modern England, the language of improvement primarily referred to schemes, projects or devices through which the economic position of the nation might be advanced, the estates or fortunes of individuals bettered, or existing resources made more productive. In the new and relatively undeveloped societies of British America, improvement carried similar connotations but it also acquired a wider meaning. It was used to describe a state of society that had been taken from the savagery of the native Indians. Not wild or barbaric, the improved South Carolina colony was settled, cultivated and civilized. Settlers who sought to improve the South Carolina Sea Islands were a part of this ideological tradition.

The name "Kiawah" signified a place where English ideals and practices regarding colonization met an unfamiliar group of cultures and landscapes. The name shifted several miles to the southwest, as a Sea Island acquired the name Kiawah. The name might signify how the English planters and farmers of the late seventeenth century perceived the Sea Island landscape. The island of Kiawah was a place that offered an opportunity for improvement if English planters accepted the challenge.

3.

John Stanyarne's Kiawah Plantation 1717–1772

Farm and plantation building was the central activity of the eighteenth-century South Carolina Lowcountry. Planters and slaves cleared land for staple crops like rice and indigo or for the production of provisions such as corn and potatoes. They also erected houses and fences, raised stocks of cattle, swine and horses, and planted orchards. The work was difficult but rewarding, for plantations gained in value, living standards rose, assets accumulated and levels of wealth and income grew to levels not seen in any other region of British America. In the process Lowcountry planters developed a new system of agriculture through experimentation as they learned by doing. The newer agricultural practices were a blend of European, Indian and African techniques that mirrored the dynamic Lowcountry population. Plantation making created economic and social inequalities as some planters fared better than others. The examination of the plantation development on Kiawah Island, South Carolina, in the eighteenth century offers insights into how planters believed a place and an environment would affect the production of staple crops. John Stanyarne was the first successful planter on Kiawah, a fact that reveals much about the relationship between the economy and the environment in colonial South Carolina.

John Stanyarne first used the Sea Island to keep his livestock herds; then beginning in the 1750s, his slaves produced indigo on Kiawah. Stanyarne understood the economic advantages the island offered because of its physical environment. The Sea Islands were ideal for containing roaming livestock, and the older soils on the backside of the island were rich soils well suited to producing indigo. Lowcountry planters took an active interest in the physical environment of their region. Stanyarne's Kiawah plantation showed how successful planters could be if they understood the relationships between the physical environment and their agricultural practices.

The South Carolina Lowcountry witnessed dramatic changes throughout the colonial period. The English settled the area, wrested control of the territory from the Amerindians and wreaked havoc among those inhabitants in the process. By 1720 the tribal groups of the Carolina Lowcountry had been decimated by disease and warfare, their lands cultivated by the English and African slaves, their economies left in disarray, as once strong tribes became periphery populations on the edges of English settlement. The nature of that English settlement also changed. The small settlement at Albemarle Point on the Ashley River moved to the tip of the peninsula at the mouths of the Ashley and Cooper Rivers. This was to be the primary port of Carolina, Charles Town. Socially, the colony became a society of aspiring planters, forming communities in which Lowcountry farmers and planters worked owner-operated farms with the aid of their families, hired servants and a few African slaves. These men laid the economic and social foundations for the large rice and indigo plantations that appeared on the South Carolina landscape beginning in the 1720s. During the eighteenth century, as the wealth, social status and economic motivations of South Carolina planters evolved, class and race divided South Carolina and created the structure for the Lowcountry's economic "golden age."

Agriculture, the process of plantation making in particular, was a central, driving force in these transformations. Settlers were attracted to the Lowcountry because of the chance to make staple crops and provisions while carving out a good life with comforts and the security of one's own land. Many eighteenth-century South Carolina settlers experienced an early death, but the survivors transformed the landscape. They built farms and plantations, an activity that allowed many to realize dreams of independence and modest prosperity, while at the same time it expanded the area of European settlement. This expansion put increased pressure on the Indians, who had to be pushed back to foster a sense of security among the colonists and to facilitate room for more land and settlement.

Sometime in the 1690s, Carolina planters began producing a staple that would profoundly change the Lowcountry landscape. Rice consumed a large portion of the region's land, labor and capital until the Revolutionary War. Rice altered the South Carolina economy by making the colonists change to producing agricultural staples and by infusing the colony with more capital and credit. Rice production also changed the colonists' sense of the land. The grain was produced on more than one type of soil and in a few different settings. During the early period of rice cultivation, planters grew rice on upland soils. This was a conventional method, as planters cleared land and depended upon rainfall to nourish the crop. The plant was also a good complement to cattle raising, as manure was used to fertilize the land and the cattle grazed upon the weeds.

Slave labor cleared the forests, planted rice, extracted pitch, tar and resin from pines, herded cattle and grew the subsistence crops. The opening decade of the eighteenth century established the viability of rice as a cash crop but its spatial expansion depended on greater numbers of cheap, ready labor. Increased production of naval stores, deerskins and salted beef for export provided the critical capital for African slave imports.

In the 1720s, planters in South Carolina reevaluated their attitudes about the landscape in which they lived. The cause of this change was the transformation of rice production. It was also at this time that one planter bought all of Kiawah Island. This purchase reflected the changing planter attitudes about the lands on the Sea Islands and the Lowcountry in general. As more slaves entered South Carolina, rice planters used more complex systems of irrigation in their rice fields. Slaves dammed rivers and drained swamps, using the fresh water to nourish the valuable crop. The Sea Islands region was not an area that supported large-scale production of rice. The sources of fresh water were scarce. By the 1720s, planters regarded the Sea Islands as specialized sites for raising livestock and producing naval stores. Kiawah, like the rest of the islands, was considered to be a backwater by South Carolina planters. Instead, planters favored inland swamp sites.

John Stanyarne lived the typical life of a South Carolina planter in a small corner of the English-speaking world. He left no diary or any revealing personal letters. We know only the bare outlines of his career: when he was born and died, the names of his wives, the ages of his children, his sources of income and his standard of living, who some of his friends were, the public offices he held and the religion he professed. Occasionally, we are provided fleeting insight into his personality, but his life remains skeletal, lacking the intimate detail needed to add flesh to a biography. We know, or at least could discover, as much or more about many other residents of the colonial South Carolina Lowcountry. Yet to study how Kiawah Island was integrated into the economy of early South Carolina, the characteristics of Stanyarne's landholding and economic patterns must be studied.

The first Stanyarne to live in South Carolina was Thomas, who migrated to the colony in the early 1670s from Barbados. The Proprietors granted Thomas Stanyarne approximately 2,500 acres of land beginning in the spring of 1675. Eight years later, Thomas died, leaving his land to be divided equally amongst his four sons and one daughter. All four of Thomas Stanyarne's sons, James, John, William and Thomas, became large landowners in South Carolina. John Stanyarne became wealthy and a member of the Carolina gentry by augmenting his land ownership and serving in colonial government. He was the recipient of grants totaling 1,210 acres on the Stono River and Bohicket Creek in Johns and Wadmalaw Islands, 610 acres in Granville County and 2,000 acres on the Pee Dee and Winyah Rivers. He served in the colonial assembly from 1696 until his death in the early 1720s. John Stanyarne's son and namesake was born in 1695. He used his father's wealth and prominence to become even wealthier than his father. Because of this wealth, the second John Stanyarne could take more risks as he built his Kiawah Island plantation. Young John Stanyarne probably received land, slaves and cattle from his father's will. Stanyarne's inheritance may have allowed the young planter to shift from semi-subsistence activities, like growing provisions and raising livestock, toward broader commercial engagements, like rice and indigo production.

The Lowcountry system of agriculture produced capital sufficient to finance expansion for those, like John Stanyarne, who were willing to take the risk. Stanyarne used accumulated wealth to acquire capital that could support staple crops and purchase slaves. In 1710, planter Thomas Nairne defined what many white South Carolinians aspired to be. A Carolina planter was "a common Denomination for those who live by their own and their Servants Industry, improve their Estates, follow Tillage or Grasing, and make those Commodities which are transported from hence to Great Britain, and other Places." Livestock still had a central place on the plantations in the early eighteenth century. The rise of staple crop agriculture, coupled with an emphasis on African slavery, allowed the Lowcountry's planter class to become wealthier. The planters' interests in the acquiring and raising of livestock changed as the elite sought more slaves and more land on which they could produce more staple crops.

Livestock raising proved an ideal industry for early Carolina, for it allowed colonists to create wealth despite undeveloped land and a limited labor force. Newcomers to South Carolina became successful livestock raisers by acquiring headright lands, buying some breeding stock, grazing animals in the unfenced woods and producing salted meat for the West Indian trade. A headright grant of land was virtually free, breeding cows and hogs cost very little and open grazing lands were free. Given the small capital investment, livestock raising provided a means of economic advancement for even the poorest settlers in Carolina. Economic mobility was possible under such conditions because of the rapid increase of livestock populations.

The process for planters whose families were already established in the Lowcountry was different. With their earnings from livestock and imports, established planters like Captain Raynor or John Stanyarne acquired laborers and accumulated land and small luxuries. Thus, livestock not only provided a source of income for early South Carolina but also represented the major form of wealth held by early estates.

The process of becoming a member of the planter class occupied a key place in the aspirations of most of the white men in colonial South Carolina. This economic and social process started throughout the Lowcountry in the last decades of the seventeenth and the early decades of the eighteenth centuries. On Kiawah Island, the process began in the first few years of the eighteenth century. Captain George Raynor and Captain William Davis, followed by Richard Peterson and Roger Moore, acquired portions of the island, roughly 1,350 acres, in order to exploit the island's economic potential. These planters bought livestock to raise on the island. The South Carolina Sea Islands were ideal places for the raising and maintaining of livestock herds. Cattle could be collected more easily than on the mainland, where many animals became unmarked and feral strays. Kiawah's somewhat milder climate made winter forage even more abundant than in the inland regions and winter shelters unnecessary. The salt marshlands of the Sea Islands, generally useless for agriculture, provided excellent grazing and eliminated the expense of saltlicks. Two types of salt marsh appear on Kiawah. Smooth cordgrass dominates the regularly flooded salt marsh and black

needle rush and salt meadow cordgrass dominate the irregularly flooded marsh. Cattle sustained themselves on both types of vegetation. The grazing in the salt marshes was at its best in the winter, because plant growth was more tender and nutritious then, and also because insects were less troublesome.

The South Carolina landscape offered advantages in raising livestock. Since cattle and hogs foraged throughout the year in marshes, savannas and forests, there was no need to provide animals with winter fodder as in the northern colonies and England. Therefore, it was possible to raise more livestock in Carolina with less labor than elsewhere. Yet there were obstacles that planters had to overcome in dealing with the stock and the landscape. The Sea Islands region was an area where deer also thrived. Before the English settled in the Lowcountry, Indians often went on hunting excursions to the coast to kill deer. The deer foraged in the canebrakes and marshes of the islands, as well as enjoying the protection that the forests offered. It is likely that once Europeans introduced cattle to the Sea Islands in the late seventeenth and early eighteenth centuries, deer populations declined because of the competition between hogs, cattle and deer for forage. The Sea Islands also posed unique problems to the livestock industry. Herders would often lose cattle in the dense forests of Kiawah. Locating an adequate supply of fresh water was also a problem, serving to keep the stock healthy and cool in the summer.

The early eighteenth-century Kiawah landowners attempted to earn income and accumulate capital by producing commodities to sell at market. Livestock was essential for these men as they attempted to improve their financial and social statuses. Planter Roger Moore, owner of half of the island between 1705 and 1717, registered his cattle mark in the colonial records. This record not only attested to the burgeoning cattle industry on the barrier island, it also indicated that more than one planter, possibly a few more, held cattle on Kiawah. The need to tag livestock implied that there were other owners of livestock sharing the same land. Kiawah landowner John Stanyarne leased land on Kiawah before he bought a part of the island. Other Johns Island planters might have followed this practice. Indian laborers and African slaves on horseback cleared stray cattle and hogs from the dense forests on Kiawah Island. Most of South Carolina's aspiring planters slaughtered cattle and hogs and sold salted meats to the West Indies.

During the height of the livestock industry on Kiawah Island, human occupation of the island was very limited. The island was suitable for livestock habitation, but not for settlers. However, African slaves lived on Kiawah in a crudely built isolated structure. The slaves' structure was situated not far from a landing on the Kiawah River, allowing access to the mainland, but sufficiently back from the marsh to be somewhat insulated from the cold winds and strong ocean breezes. The archaeological remains strongly indicated an ephemeral structure constructed using either logs or perhaps little more than wattle, daub and thatch. This structure on Kiawah was similar to another structure found on the Sea Islands by John Lawson, who described a cattle herders' dwelling: "one side of the Roof of this House was thatch'd with Palmetto-leaves, the other open to the

During the early eighteenth century, cattle on Kiawah Island bore these marks. These are the registered cattle brands of planters Roger Moore and John Stanyarne. *Courtesy of the South Carolina Department of Archives and History.*

Heavens." This structure represented a single dwelling of cattle herders or stock tenders. The structure was small, so only a few slaves lived there at one time. These slaves did not have any skills in planting rice, so they were sent by John Stanyarne to keep after his herds on Kiawah. If these slaves had rice-planting skills, they would have been on Stanyarne's Johns Island plantation helping to produce a crop. It is also possible that a few of John Stanyarne's slaves had skills as cattle herders. Slaves who tended large herds of cattle were common in colonial South Carolina. Clearly, these slaves had a good deal of freedom on the nearly isolated island.

In 1717, the economic landscape of Kiawah Island changed drastically. A man in his early twenties, John Stanyarne, purchased half of Kiawah from planter Roger Moore. Stanyarne paid £1,000 for Moore's half of Kiawah, money that may have come from his father's will. The role of the Kiawah landholder changed when John Stanyarne moved his livestock herds to Kiawah. He was of a different generation than the previous planters on Kiawah. He was born and raised in South Carolina, and he certainly understood the impact that the new market ethos had for the colony. Stanyarne typified the eighteenth-century South Carolina planter: an aggressive, hard-working, rather materialistic man who constantly sought to increase his wealth and landholdings.

By 1770 South Carolina was one of the leading agricultural exporters in the British Empire. The colony contained hundreds of rice plantations worked by thousands of African slaves. In that year, Carolina produced approximately 160,000 barrels of rice, and the colony was the home for almost 75,000 slaves. Yet seventy years earlier Carolina exported only 2,000 barrels of rice, and the colony contained only 3,000 African slaves. In 1700, Carolina's principal exports were deerskins and provisions such as beef and

pork. In 1700, Carolina was still a frontier colony where livestock raising was the leading agricultural pursuit.

Although South Carolina was still a livestock-raising colony in 1700, rice growing was challenging the industry's economic dominance. Carolinians began experimenting with rice in the 1690s, learning the techniques for raising, harvesting and threshing this grain from black slaves who had grown rice in West Africa. By 1700 South Carolina was planting rice for export to Europe. Many colonists soon combined rice growing with livestock raising. Planters cultivated rice in the "low moist Lands" along rivers while grazing livestock in the surrounding woods. By 1712, rice planting had surpassed livestock as the leading agricultural pursuit. In that year, Carolina exported 12,727 barrels of rice, which were valued at approximately £40,000 sterling. The estimated value of meat exported that year was between £7,000 and £10,000. Though South Carolina became the largest rice producer in the colonial South, cattle raising did not disappear. As late as 1719, more slaves worked in the livestock industry than in rice planting. The planters of South Carolina began to adapt their plantations for the cultivation of staple crops, particularly rice and, later, indigo.

The tremendous amount of hard labor, the wearing and dangerous nature of the work and the full yearly cycle of growing and harvesting a rice crop influenced the pattern of life and commerce of colonial South Carolina. The hard labor was supplied, of course, by African slaves. The profits earned by the planters greatly altered the landholding, tax and business patterns of the colony. Most of the export trade of the colony was conducted in the winter and spring when this bulky and lucrative staple was available to ship to England. Winter was the only time of year when activity on a rice plantation slackened, and some of the hands were put to other tasks, such as clearing more land or catching stray cattle.

The series of imperial wars beginning in 1739 disrupted South Carolina's rice trade and stimulated planters to pursue another export crop. As the market price of rice sank to unprofitable levels, some planters who had enough capital and land turned to producing indigo, which was valuable even in small quantities and which could be transported to England in large quantities in just a few well-armed English ships. John Stanyarne switched his emphasis from his rice-producing Johns Island plantation to his other land, in search of a more profitable commodity.

The Sea Island landscape was well suited for the production of indigo. Intense indigo production began in the late 1740s, altering again the way that South Carolina planters regarded the land of the Sea Islands. The islands became specialized sites for indigo. Charles Woodmason, writing in the 1750s, described "Wild Indico," which was "found on (and agreeing with) our sea-islands and seashore lands, where the soil is light and sandy." Woodmason believed that the real advantage the Sea Islands had in growing indigo was not the soils but a climate that permitted early planting and harvesting "before the other sorts are dry or fit to pack." Woodmason may have exaggerated some of his claims about indigo production, yet some planters did acknowledge that Sea Island indigo seed was desirable and may have been superior to most other seeds.

Indigo joined corn, provisions and cattle production on Stanyarne's Kiawah plantation. He moved slaves from Johns Island over to Kiawah to help in the production of another labor-intensive staple. A delicate crop, indigo required careful scrutiny, although only at particular times in the growing season. After planting in the spring, indigo needed little attention until periodic harvesting of the leaves in July and continuing through the fall. Most South Carolina plantations could only cut the weeds two or three times, but because of the longer growing season on the Sea Islands, slaves cut Kiawah indigo once or twice more. The soils of Kiawah Island also favored indigo production. The site that Stanyarne chose for the plantation contained well-drained, moist, light soils. As Henry Laurens once wrote of indigo produced by John Stanyarne, it was "always as dry as Indigo can possibly be."

A discussion of Stanyarne's plantation settlement reveals how much importance he placed into his landholding and economic activities on Kiawah Island. Stanyarne built a plantation settlement on the eastern bank of Salt House Creek, just a few hundred yards from the Kiawah River. These structures included a modest house and a few slave cabins. It is difficult to determine exactly when this settlement was built, although clues exist. Stanyarne began his indigo production on Kiawah by 1757. Strong evidence suggests that Stanyarne had been producing the crop on the island for several years prior to the late 1750s. Henry Laurens bought some of Stanyarne's indigo in 1757, adding that the Kiawah planter "has heretofore always shipped his crop on his own account." Laurens's familiarity with Stanyarne's business habits strongly suggests that Stanyarne had been selling indigo to Laurens for at least a few years previously. The existence of a quality and lucrative indigo crop caused Stanyarne to build permanent homes for slaves who produced his indigo on Kiawah. A house was built for an overseer, though it is unlikely that Stanyarne ever lived on Kiawah.

In the mid 1760s, Stanyarne built a more expensive, sturdy overseer's house on the opposite bank of Salt House Creek. This may correlate with a rise in the indigo production in the colony in general and on Kiawah in particular. Stanyarne's Kiawah plantation may have had a miniature version of a port on the Kiawah River. Laurens noted that the Kiawah planter shipped indigo from his plantation directly to London. Ships from Savannah and Beaufort could have made a small detour to Stanyarne's dock adjacent to his Kiawah plantation to pick up Kiawah indigo and Johns Island rice, cattle and provisions.

In December 1772, John Stanyarne died. A month later, an inventory was taken of the estate. The value of his inventoried estate totaled more than £146,000 currency. Only one-fifth of South Carolina inventories in the late colonial period had a value of more than £2,000. Clearly, Stanyarne was a very wealthy man for his time and place. Other evidence in the inventory revealed the status and wealth of the planter. Two-thirds of the movable property included in the inventory was slaves. In late colonial South Carolina, slave wealth was generally half of total wealth of decedents. Stanyarne's estate included five sets of indigo vats, presses and pumps. While some South Carolina

planters considered indigo production a temporary solution in diversifying their sources of income away from rice, Stanyarne regarded his Kiawah indigo plantation as a stable and permanent part of his enterprises. The value of the indigo crop was £6,100, a figure that also attested to the skilled, and therefore valuable, slaves that worked on Kiawah Island.

Studies of probate records by William G. Bentley and Alice Hanson Jones provide a region-wide perspective on the wealth of Lowcountry whites. These studies clearly confirm the importance of slavery to the colonial South Carolina economy. In most years more than three-quarters of the decedents owned slaves, while among those who earned their income from agriculture that proportion was greater than 95 percent. There were, on average, nine to twelve slaves per estate in the 1720s and 1730s, fifteen to eighteen in the 1740s and 1750s, and twenty-eight by 1774. Slaves accounted for 40 to 50 percent of the movable wealth of South Carolinians from the 1720s to the 1760s and for an extraordinary 68 percent in 1774. The data also reflects the prosperity of Lowcountry whites in the decades before independence. Mean movable wealth per decedent doubled between 1740 and 1760 and grew at an even faster rate in the next fifteen years. In 1774, decedents who entered probate in the Charleston district were worth £2,700 sterling on average, more than six times the figure for the thirteen colonies as a whole. Nine of the ten wealthiest men to die in the mainland colonies of British America in 1774 had lived in the South Carolina Lowcountry.

John Stanyarne's inventory revealed how the planter successfully adapted his agricultural practices to the Sea Island environment. In addition to staple crops, his plantations produced provisions, such as corn, peas and potatoes. His Kiawah plantation produced a good deal of corn, with over 2,500 bushels included in the inventory. Also included were 300 bushels of potatoes, as a well as a parcel of peas. The value of the corn was almost £2,100, more than half of the value of the rice crop and a third of the value of the indigo crop. Stanyarne diversified his enterprises on Kiawah, producing different types of commodities, to maintain Kiawah Island's links to the Lowcountry economy.

As the production of rice began to make many South Carolina planters wealthy in the 1720s, John Stanyarne bought all of Kiawah Island. The Sea Islands offered an excellent place to raise livestock. How planters perceived the usefulness of the Sea Islands underwent a change in the middle of the eighteenth century. Unable to support rice production, indigo thrived on the islands, mirroring the trend on other Sea Islands. It was this plant, the imperial dye, which brought the Sea Islands into the staple crop economy.

The Sea Island tradition of producing a unique and valuable staple crop began with indigo. The relationship between a crop, indigo, and later cotton, and the Sea Island landscape began in the middle of the eighteenth century. Planters perceived Sea Island plantations as specialized sites for livestock raising and indigo. Yet the islands were still on the periphery of settlement in the few decades before the Revolution.

John Stanyarne, the owner of Kiawah Island for most of the colonial period, lived on neighboring Johns Island. Perhaps Stanyarne wanted to live on a more settled, secure place than a barrier island. Instead of being a small piece of a merchant's integrated landholdings, Kiawah had become a part of the plantation enterprises of a wealthy planter. Stanyarne and his slaves overcame the environmental problems that challenged the delicate workings of an indigo plantation.

4.
REVOLUTIONARY CHANGE ON KIAWAH
1772–1799

The British expedition to conquer Charles town began in December 1779. By the middle of February 1780, the British fleet arrived at the North Edisto Sound, between Edisto and Simmons (Seabrook) Islands on the South Carolina coast. The British invasion of the South Carolina Sea Islands altered the landscape in many ways. The army wrecked plantations, ran off livestock and confiscated property. The inhabitants of the islands became involved in a partisan war, as neighbors and friends discovered that they held different loyalties. These developments were particularly obvious on Kiawah Island, as the two plantations on the island struggled to survive against the changing economic, political and social landscapes of the Revolutionary era.

The war came to the Lowcountry in June 1776. The Americans repulsed the British attempt to take Charles Town early in the war. Military action did not return to the Lowcountry until late 1779. By February 1780, British troops were using Johns Island as a staging area for their assault on Charles Town. Charles Town fell to the British force in May. Sometime in the latter part of 1780, British troops occupied Kiawah Island, destroying one of the two working plantations on the island.

Under pressure to launch an offensive against South Carolina during the spring of 1779, Sir Henry Clinton, the British commander in chief, announced his decision to extend the war into the Lowcountry. "This is the most important hour Britain ever knew," the commander declared. "If we lose it we shall never see another." In April 1779, British General Augustine Prevost led a small army up the coast from Savannah. Prevost only sought to draw an American army away from attacking British-held Savannah, but resistance was so light, and panic so widespread, that the army almost took Charles Town. Prevost and his army eventually withdrew back to Georgia, but the

men brought back with them loads of plunder. The British expedition took their spoils from the Sea Islands south of Charles town. The plunder included casks of indigo, furniture, slaves and livestock.

In the early 1770s, John Stanyarne's Kiawah Island plantation was a major indigo producing enterprise. The perception of the value and usefulness of Sea Island land changed throughout the eighteenth century. These trends heightened on Kiawah Island during the American Revolution as agricultural production became difficult. Stanyarne's will halved the island, making the competition for resources, so important in an agriculturally based economy, more intense. The two families among whom the land was divided left very little evidence as to the activities that took place on Kiawah Island during the Revolution. Many plantations in the South Carolina Lowcountry struggled with the challenges of the wartime economy and military occupation. How the Kiawah planters reacted to the stresses of this period reveals much about their goals and attitudes.

Stanyarne's will divided Kiawah Island between two of his granddaughters, Elizabeth Raven Vanderhorst and Mary Gibbes Middleton. Wills were self-conducted surveys of the identification and relative importance of different relations within the family by the deceased. Most property went to spouses and children if they were still alive, but the specific terms of division could vary with the size of the family, the age of the children and with other economic and social considerations. Stanyarne died at age seventy-seven, so his children were themselves parents and grandparents at the time of his death. Stanyarne's only son died ten years before he did, so none of his heirs had Stanyarne as a last name. In turn, most of the property in his will went to other families. A study of Charleston County wills indicates that men who died without a wife and with adult children commonly left property to grandchildren.

Since a married woman could not own property in eighteenth-century South Carolina, the husbands of John Stanyarne's granddaughters held title to the two moieties of Kiawah Island. Mary Gibbes Middleton inherited the half of Kiawah that contained the lucrative plantation complex maintained by her grandfather. Mary's husband, Thomas Middleton, came from another prominent, slaveholding Lowcountry family. He was educated in England and then returned to Crowfield, his father's estate on the Cooper River north of Charleston. The couple married in November 1774, and a year later they produced a child named after her mother, Mary Gibbes Middleton. The elder Mary died a few weeks after giving birth, and the child became an orphan in August 1779.

Elizabeth Raven Vanderhorst inherited the eastern half of Kiawah Island. Her husband was Arnoldus Vanderhorst, a prominent South Carolina patriot and planter. Arnoldus's grandfather owned two Charleston town lots and a large plantation on the Wando River. Raised in a family of means, Vanderhorst was an officer in the South Carolina Militia, a member of the Second Provincial Congress and a senator in the Jacksonborough Assembly of 1782. After the Revolution, Vanderhorst served

Thomas Middleton married Mary Gibbes in 1774. He was involved with Kiawah until his death in 1779. He is portrayed with his daughter Mary Gibbes Middleton. *Courtesy of the Historic Charleston Foundation.*

as intendant (mayor) of Charleston in the late 1780s, and he was governor of South Carolina from 1794 to 1796.

The Revolutionary era has often been interpreted by historians as a watershed in American history, for the economy as well as for political and social developments. It is therefore interesting to note that economic historians have neglected the years of the war and its immediate aftermath. The concept of a watershed contrasted the late colonial and early national economies, but historians have done little work on the transition period. Joyce Chaplin has noted that planters in the lower South responded to the Revolution by diversifying and expanding their economic activities and interests, but her examination of planters' economic activities during the war is brief.

The evidence for studying economic activities on Lowcountry plantations is generally very sparse. The war disrupted many aspects of plantation life, not the least of which was record keeping. The loss of slaves, the insecurities of transportation and the questionable availability of cash and credit often hindered planters' efforts. Trade was forced into new, sometimes clandestine, usually less well-documented channels. A study of the South Carolina Lowcountry's wartime economy provides an opportunity to assess the success of the colonial economy and to explore the consequences of the export-led process of growth and development of the eighteenth century.

Beginning in February 1775, South Carolina instituted an embargo against British imports. Coupled with the fact that the two Kiawah plantations were in the building stage, possibilities emerge about economic activity on the island early in the war. The early owners of Kiawah Island valued the land as a good place to raise livestock. The production of indigo on the Sea Islands changed planters' perceptions of the land as places that could support staple crops. Planters probably maintained these attitudes into the Revolutionary era. The once lucrative Stanyarne plantation was now in the hands of Thomas Middleton. Middleton produced rice on his estates, and he could have chosen to produce provisions and indigo at the old Stanyarne plantation. No extant records have indicated that Mary Middleton owned any slaves, so her husband might have sent some to Kiawah from his rice-producing plantations on the Cooper River. Arnoldus Vanderhorst and his slaves may have begun to produce indigo on his half of Kiawah.

In November 1775, Thomas's wife died, putting the property into trust for his daughter. John Stanyarne's will stipulated that should Mary Gibbes Middleton die, only her heirs could inherit the western half of Kiawah. Therefore, Thomas did not legally own the property anymore, his daughter did. Since his daughter was very young, the actual control of the Middleton half of Kiawah might have remained in Thomas's hands. Trusts usually gave the income from a particular piece of land, in this case a plantation, to the heir. However, it is not possible to determine the exact arrangements of the trust. Thomas Middleton died in August 1779, thus allowing Robert Gibbes, the young Mary Gibbes Middleton's grandfather, to oversee

the western half of Kiawah. Gibbes's oversight of the plantation showed planters' commitment to plantation agriculture.

The American Revolution had an enormous impact on an agrarian economy dependent upon overseas commerce. Large-scale economic production on Kiawah was possible for the first few years of the war, given the isolation of the island and the lack of military activities in the South Carolina Lowcountry. It is likely that both plantations continued to export indigo throughout the 1770s. A Lowcountry planter noted in March 1778 that "the Planters of Indico were putting large Proffits into their pockets." The high prices realized for indigo during the Revolutionary era influenced the planters on Kiawah. The Vanderhorst half of the island experienced significant growth during the 1770s, and indigo might have financed the expansion. Vanderhorst and his slaves built a house, slave dwellings and a kitchen, and cleared land for agricultural production by 1780.

The outbreak of war between the colonies and Britain also affected the Lowcountry's black population. Robert Olwell divided the experience of the region's slaves into three separate periods. The first period coincides with the first year of the war, 1775–76, and included what he saw as a domestic struggle between masters and slaves. The second period began with the British occupation of the South Carolina coast in 1779. The occupation saw a further breakdown of the patriarchal system upon which slavery was based. The British army lured blacks into their camps, thus giving the slaves a sense of freedom and accomplishment. However, Olwell's divisions seem too pat. It is entirely possible that slaves living and working in the outlying areas of the Lowcountry, like the Sea Islands, had an entirely different Revolutionary experience. A planter noted during the first year of the war that news of a possible British attack caused "many of our Town's people to begin packing up their valuable Effects, in order to remove them with Wives, Children into the Country." Some of these possessions certainly included slaves, as planters sought safer ground, away from the vicinity of Charles town. It was possible that the two Kiawah planters Thomas Middleton and Arnoldus Vanderhorst sent slaves to Kiawah from their estates on the Cooper and Wando Rivers.

Two British invasions trampled across the Sea Islands beginning in 1779. Troops under Prevost and Clinton plundered plantations and towns from Beaufort to Charles Town. As the war arrived in the Lowcountry, the agricultural production on many plantations changed. Plantations might have increased their production of provisions, like corn and potatoes, to meet the demands of the British Army's commissary. However, the scarcity of food during the British occupation of Charles Town suggested that many plantations stopped operating altogether. Many plantations never recovered from the plundering by the two armies. The destruction severely disrupted agricultural production. Neglected or devastated by the war, stripped of tools and livestock, "the plantations have been nearly ruined and all with very few exceptions great sufferers," wrote Eliza Lucas Pinckney. "Their Crops, stock, boats, Carts, etc. all gone taken or destroyed and the Crops made this year will be very small by the desertion of the Negroes in planting and hoeing time."

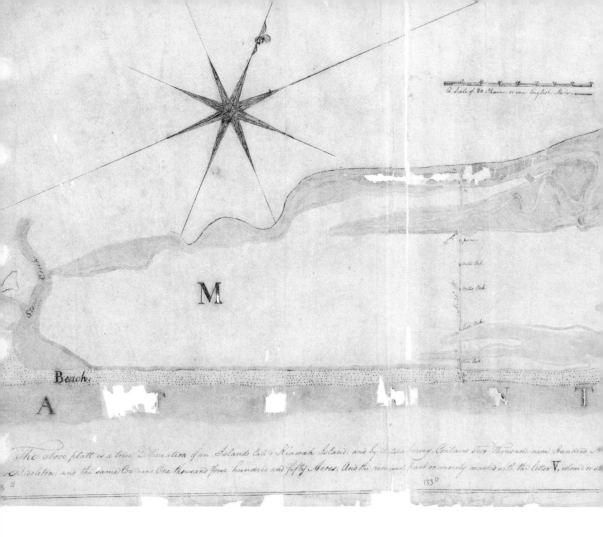

This is the 1775 plat made of Kiawah. Notice the carefully drawn line of division between the two plantations. "M" stands for Middleton, "V" stands for Vanderhorst. *Courtesy of the South Carolina Department of Archives and History.*

The British army's use of Johns Island as a staging area for their assault on Charleston increased tensions and stresses for the planters on the Sea Islands south of the city. The troops scared many inhabitants as they scoured plantations, looking to "collect information about the enemy and to hunt up Negroes and livestock." It is not likely that foraging parties came to the Kiawah plantations before the British occupied Charleston. The troops marched north and northeastward, away from the island, and Johns Island represented a well-stocked pantry to the invaders. The two British invasions profoundly affected life on the islands south of Charleston. Edisto, Seabrook, Johns and James Islands suffered at the hands of the king's troops. Kiawah Island was an exception in that it was not occupied by British troops during either of the invasions. After 1779, the island might have been seen as a safe haven. The two plantations on the islands might have been bulging from the extra slaves, valuables and provisions sent to the island. The

44

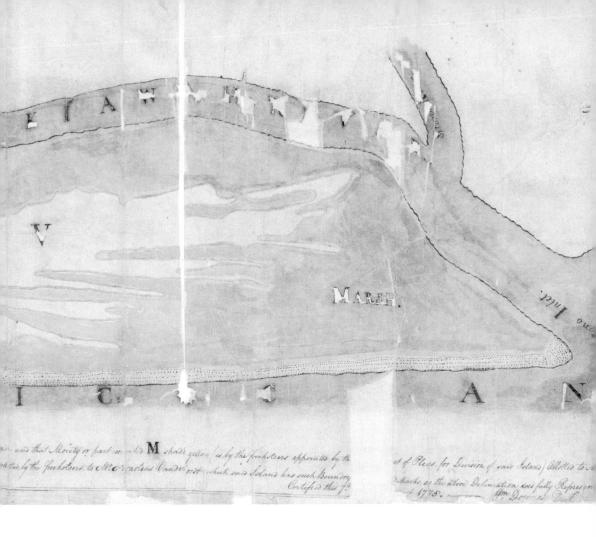

and that Moiety or part *illegible* M shade *yellow* is by the freeholders appointed by the *illegible* to Mr Arnoldus Vanderhorst which said Island has such Boundary, Certified this 7th *illegible* of Places for Division of said Island Allotted to *illegible* Marks, as the above Delineation does fully Represent *illegible*

visit of General Nathanael Greene's staff in 1782 also shows this perception. The ailing soldiers wanted a place to rest, away from the stresses of military life.

British troops finally made their way to Kiawah Island in late 1780. In September, British commander Lord Cornwallis announced the sequestration of the estates of a number of "wicked and dangerous traitors." Sequestration was to apply to three categories of people: those who had abandoned their plantations and joined the Patriot forces, those who "acted under the authority of the Continental Congress" and "those persons who by an open avowal of rebellious principles or by other notorious acts, do manifest a wicked and desperate perseverance in opposing, to the utmost of their power, the establishment of His Majesty's just and lawful authority." British officials included Arnoldus Vanderhorst in the list of Patriots that deserved punishment. Shortly afterward, a detachment of British troops landed on Kiawah Island and destroyed Vanderhorst's plantation settlement that included a house, slave quarters, lumber and provisions. The British left the other plantation on the island, run by Robert Gibbes, untouched. This episode showed that some planters took sides during the Revolution to save their plantations, or at least their economic well-

being. While Vanderhorst was a staunch patriot, Robert Gibbes changed his loyalties during the Revolution.

Early in the war, Robert Gibbes shared similar revolutionary views like his friends Edward Fenwick and Henry Middleton, a signer of the Declaration of Independence. Gibbes's political loyalties might have begun to change in the spring of 1779 when British troops under Prevost sacked Peaceful Retreat, his plantation on Johns Island. Gibbes, afflicted with gout, barely escaped as the troops drove off cattle and slaves and helped themselves to the plantation's wine and food supplies. After the surrender of the city of Charleston in May 1780, hundreds of Lowcountry residents came forward to take an oath of allegiance to the king. There were many reasons for Carolinians to submit, if grudgingly, to British rule. The American military cause looked grim in 1780. The authorities only required that no overt aid be given by parolees to persons in rebellion. Planters appreciated the reopening of the port, a return to sterling instead of paper money and a more stable climate in producing and processing staple crops.

Further evidence of Gibbes's political conversion came from the second British invasion of Johns Island in February 1780. Lord Cornwallis established his headquarters in Peaceful Retreat, Gibbes's plantation, a few days after the British landed on Johns Island. The general stayed for several days, and then a regiment of Hessian troops was stationed on the plantation. It is conceivable that Gibbes supplied the troops with provisions and might have even let the invaders use his slaves for hauling cannon or digging fortifications. It is apparent that by the fall of 1780 Robert Gibbes had made his Loyalist sympathies known to the British authorities in occupied Charleston. The fact that one Kiawah plantation burned while the other survived might be attributed to the rapidly changing political climate of the Lowcountry during the Revolution.

Beginning in early 1785 Arnoldus Vanderhorst II tried again to build a plantation on the Kiawah Island landscape. Salvaging what materials he could from his previous settlement of Kiawah, Vanderhorst attempted to make the plantation a diverse, profitable enterprise. The planter and his slaves followed John Stanyarne's precedent of raising livestock and producing provisions for other plantations, while attempting to grow a single crop, indigo, on a larger scale. Joyce Chaplin wrote that after the crisis of the American Revolution, the planter population fell into two categories: innovative and responsive. The innovators looked for ways to change agriculture to make themselves wealthy. The responsive planters changed their methods of production only if market conditions gave them little other choice. Kiawah's planters changed their agricultural production because of market conditions, yet they also changed production because of the island environment. After several years of indigo production in the late 1780s and early 1790s, Vanderhorst began producing sea-island cotton. Both crops showed the flexibility of the Kiawah landscape as well as the planters' commitment to staple crop agriculture. As two plantations developed on Kiawah Island in the early nineteenth century, tensions mounted in the struggle over the resources that the barrier island offered. The building of new plantations, the dispute over resources and the planters'

efforts to coax some profit out of the island environment characterized the tensions of the post-Revolutionary era.

A plantation account book kept by Arnoldus Vanderhorst from 1785 until 1799 reflected the planter's investment in and commitment to the agricultural landscape of the Lowcountry. The account book contains about seventy pages and includes not only Vanderhorst's Kiawah Island and Wando River plantations but also contains accounts concerning a schooner, his Charleston houses and members of his family. Vanderhorst still kept his accounts in British pounds, not in the American dollar. Arnoldus Vanderhorst, unfortunately, did not record all of his financial dealings in this account book. However, the surviving accounts provide glimpses of economic activity on his plantations and reveal how the plantations related to the Lowcountry environment and economy.

Recognizing the precedent set by John Stanyarne, Arnoldus Vanderhorst understood that the plantation that produced staple crops was the most effective way to make the Sea Islands, particularly Kiawah, a part of the lucrative economy of eighteenth-century South Carolina. Vanderhorst's account book revealed the efforts a of Lowcountry planter to rebuild and reestablish a Lowcountry plantation. During the 1780s in the South Carolina Lowcountry, cultivation of indigo gradually diminished. In 1783 the Charleston collector of the customs reported that planters exported 827 casks of indigo during the entire year. By 1790 exports of indigo rose to 1,649 casks, but six years later the amount fell to 490 casks. With this decline, British textile manufacturers persuaded Parliament to encourage planters in other British colonies. The imperial preference shifted to India and the East Indies. Planters in Guatemala, Brazil, French Louisiana and South Carolina had to begin cultivation of other crops or face severe financial hardships.

Vanderhorst's postwar Kiawah plantation began producing indigo in 1785. The first year of the account book records that slaves constructed vats, boxes and pumps for indigo production. A debit also appears for "pipes and Tobacco for New Negroes," possibly indicating that the planter brought newly bought slaves to his Kiawah plantation expressly for indigo production. Vanderhorst sold four casks of indigo in December 1785 for seventy-two pounds. Interestingly, that entry was the only credit to the plantation recorded in the entire account book related to a staple crop. During the next few years, Vanderhorst still purchased indigo seed and repaired his machinery for production. It is possible, even likely, that Vanderhorst's Kiawah plantation produced and sold indigo into the 1790s. For whatever reason the planter did not keep a complete account book for his plantations.

Arnoldus Vanderhorst's Kiawah plantation produced a variety of goods. According to the accounts, the plantation received most profit when the planter sold lumber from the island. The sale of wood from Kiawah might have complemented the tasks of preparing land on the island for cultivation. Vanderhorst sold palmetto logs to several people, possibly for firewood. He also sold over 120 logs to the state, for use in rebuilding Fort Johnson in Charleston Harbor. His Kiawah plantation produced a diverse array of provisions including corn, turnips, peas, eggs, butter and lime. These products provided sustenance

for slaves living on Kiawah as well as providing food for Vanderhorst's household in Charleston. The economic crises of the late 1780s forced Arnoldus Vanderhorst to maintain a self-sufficient barrier island plantation.

Agricultural change involved a difficult, almost wrenching social process. Such shifts were not matters of simple economic expediency. Considering the expertise on the part of the planters and their slaves in producing indigo and cotton, it was difficult to expect early nineteenth-century South Carolina planters to jump from staple to staple without encountering large problems. The Sea Island landscape added to the level of difficulty for the planters. The resources of the island again challenged Kiawah's planters.

The change brought to the Sea Island landscape by the American Revolution helped prepare the region for economic change. The planters proved themselves to be truly committed to commercial agricultural production in responding to the stresses brought on by the war. The planters gradually stopped producing indigo and began to produce a commodity even better adapted to the Sea Island environment: cotton.

During the last week of August 1782, a party of American officers made an excursion to Kiawah Island, South Carolina. A number of the general's staff had become ill, so the American commander General Nathanael Greene petitioned the British commander, General Alexander Leslie, for permission to use Kiawah Island as a place where his ailing staff could rest and recover. Leslie granted passes to the American soldiers and their attendants. Traveling to Kiawah in the late summer of 1782 were Catherine Littlefield Greene, the general's wife, Robert Johnson, the camp surgeon, and staff officers Nathaniel Pendleton, William Pierce and Lewis Morris. Also part of the group was Colonel William Washington, the hero of the battle of Cowpens. The group stayed in the Stanyarne house on the island. Colonel Lewis Morris, suffering from malaria, reported to Ann Elliot, his fiancée, that the time "was spent in reading, conversation, etc., the afternoon in riding upon an extensive beach, gazing at the wide ocean and plunging into its waves." The visitors to the island enjoyed the beautiful landscape, yet they could not have ignored how the American Revolution had changed the economic and political landscape of South Carolina.

The landscapes of Kiawah Island had changed rapidly as well. John Stanyarne's death just before the Revolution had split the island into halves. The war affected agricultural production on the island, probably causing output to decline. The social landscape of Kiawah became more complex, because the two families owning plantations on the island held different loyalties during the war. The two Kiawah plantations during the Revolution show Lowcountry planters' determination to maintain profitable places for agriculture. The Gibbes and Vanderhorst plantations also exhibited the dynamic, unstable natures of Lowcountry places during the American Revolution. The Gibbes plantation operated throughout the war, producing mostly provisions and indigo. After British troops destroyed the Vanderhorst plantation in 1780, the planter rapidly rebuilt his enterprises and began producing commodities that his first venture had produced. Kiawah's planters were determined to survive another period of economic instability.

The Kiawah plantations enjoyed the advantage of being inaccessible during the British occupation of the South Carolina Lowcountry. Kiawah Island was seen as a safe haven for soldiers, slaves and planters alike. This development highlights the relationship that the Kiawah plantations had with the rest of the Lowcountry. Kiawah was not a remote place, cut off from the activities of planters on the rest of the Sea Islands, or even Charleston. The little kingdoms of Vanderhorst and Gibbes proved their resiliency during this period, proving the planters' determination to maintain wealth, land and property.

5.

Two Neighboring Antebellum Plantations: The Shoolbreds and the Vanderhorsts 1800–1860

Social class, economic activity and wealth in the South Carolina Lowcountry rested upon each planter's ability to wrest significant agricultural production from his lands. The American Revolution, however, unleashed crises that threatened economic stability in the Lowcountry. After the war, the plantation belt of colonial South Carolina expanded upstate, expanding the market economy to places that had not yet witnessed the boom that staple crop agriculture production offered. The changing and expanding market economy also affected how planters regarded the land on the Sea Islands. During the colonial period, cattle, rice and indigo production shaped the way that most planters perceived natural resources and the usefulness of the different types of land in the Lowcountry. Starting in the 1790s, a new staple crop changed the economy of the Sea Islands. Planters discovered new uses for their lands as sea-island cotton dominated the agricultural lands of coastal South Carolina. Sea Island planters invested the culture of this high-quality fiber with associations that gave it more than economic value, and sea-island cotton plantations became distinctive features on the coastal landscape. Planters living on the fringes of the market economy in the 1780s until the 1800s actively sought to enter commercial agriculture, which featured a market dominated by staple crop cotton. The two Kiawah planters of the early nineteenth century, James Shoolbred and Arnoldus Vanderhorst II, held property on a barrier island that struggled to regain its footing in the post-Revolutionary market economy.

Changes in the economy of the Lowcountry seemed ready to change the social relations between plantations. When Sea Island planters abandoned indigo production and took up cotton culture, they augmented their slaveholdings and devised ways to maintain the old social relations of production. The nature of the new market economy

affected planter households by demanding a greater degree of household production. The efforts to bring outlying areas of the state into the tendencies and productions of the new, cotton-based market economy revealed much about the economy, planters and the places themselves. Sea Island planters survived a period of rapid change and created a society even more patriarchal and gentry-dominated than that of the colonial era. Sea-island cotton became not only a commodity adapted to the Lowcountry environment, but it also became a product that reinforced social values. Planters developed different grades, or categories, of the crop that also became an index for reputation. Just as planters developed ways for growing certain staples that shaped the environment, so they continued the process of shaping nature by placing the crops into categories of economic quality and social meaning. Planters who primarily grew sea-island cotton, like the two planters on Kiawah Island, dealt in pride, reputation and honor. These tensions appeared on the social landscape of Kiawah Island in the first decades of the nineteenth century.

In late October 1801, Arnoldus Vanderhorst's overseer, William Nicks, wrote to his employer about the conditions of the Kiawah Island plantation. The overseer painted a rather grim picture of the plantation's harvest. Nicks wrote, "the cotton field corn has not turned out much." Three days later Nicks reported that "the Cattle Corn is in and only made 18 Rice barels fool [*sic*]. The cotton blows so fast that I cannot get time to do anything Elce." Nicks also reported that the "high tides has at last tore away the new dam around the marsh near the landing." Slave artisans, helping to renovate the Vanderhorst plantation, were having problems keeping up with the workload. Nicks claimed that he had to "flog several of the carpenters to start them." The Kiawah landscape proved difficult to manage during the harvest of 1801, yet the two plantations on the island continued to turn out commodities. In addition to staple crops, the two Kiawah plantations produced lime, dairy products and lumber and raised livestock. But Shoolbred and Vanderhorst counted on sea-island cotton to make the bulk of the profits for their coastal estates. As the nineteenth century began, the two plantations on Kiawah Island competed for natural resources that seemed so plentiful to the two planters.

Nicks may have exaggerated the bad conditions on the Vanderhorst lands, but he had several reasons to be apprehensive about the workings of the plantation and his ability to master them. Managing the plantation meant disciplining and ordering the slave force and the environment into a well-regulated system. A specialized agricultural system, including both a highly organized landscape and a disciplined slave force, was difficult enough to achieve. In addition, the plantation was increasingly vulnerable to disordering forces generated within it and acting upon it from without. Because of their location on the coast, the two plantations on Kiawah Island were especially vulnerable to outside forces of disorder. Hurricanes, a brief occupation by the British, the beginning of a cotton-producing enterprise and low profits had strained Nicks's abilities and caused General Vanderhorst to consider whether rebuilding his Kiawah plantation was truly worthwhile. Each imposition of order upon the land brought new challenges, and

good management required hard work, improvisation, resilience, good judgment and attentiveness. In the process of shaping the environment into a productive agricultural landscape, Nicks, Vanderhorst, Shoolbred and other plantation managers and owners were forced to maintain an unrelenting and dynamic dialogue with disorder.

Plantations did not simply organize labor and resources for productive ends; they also deeply connected culture and agriculture. As planters and their slaves molded the Lowcountry environment, plantations constituted agro-ecological systems that restructured biological processes for agricultural purposes. All such systems, designed to produce crops for export, reduced the diversity of organisms that existed in the ecosystem that these replaced. Planters who created these new systems had to manage them carefully to maintain the balance between agricultural practice and natural forces for continued productivity. The systems that Kiawah planters developed for producing indigo and cotton required manipulations of the island's environment and therefore also demanded constant maintenance and repair. Kiawah Island's plantations produced both high-quality indigo and cotton, so clearly the relationship between the agricultural landscape and staple crop production was important on the barrier island. Planters and their slaves had to know how to judge the soil. Decisions on exactly where to plant cotton or indigo were essential to the success of the crops, and therefore the entire plantation. Arable land was limited on Kiawah Island because of the variety of soil types that appeared on the island. Being on the coast, the island was also susceptible to hurricanes. A tropical storm in August or September could flood large sections of cultivated land.

From the time of the first English owner of Kiawah Island in 1700 until the last decade of the eighteenth century, none of the landowners on the island actually lived there. During most of the colonial period, John Stanyarne saw cattle raising, the production of provisions and indigo production as economic activities that complemented his other enterprises. Once cotton production started on Kiawah, the two planters on the island built houses and lived, at least part of the year, on their Kiawah estates.

Changes occurred in the ownership of the western half of the island in the early 1790s. Mary Gibbes Middleton took over her Kiawah property on her eighteenth birthday in 1793. Her grandfather, Robert Gibbes of Peaceful Retreat Plantation on Johns Island, died the following year. In 1790, the estate held twenty slaves, most if not all of them working on Kiawah. In 1797, Mary Middleton married James Shoolbred. Shoolbred served as the British consul to America under the administration of William Pitt. He carried on the tradition of Kiawah landowners as a wealthy man with transatlantic connections. No Shoolbred plantation papers have survived, but a few state and federal records provide hints at what occurred on the Shoolbred-owned portion of Kiawah Island.

James Shoolbred began building a new plantation on Kiawah once he acquired the property in the late 1790s. Once Shoolbred located the site for his plantation on the

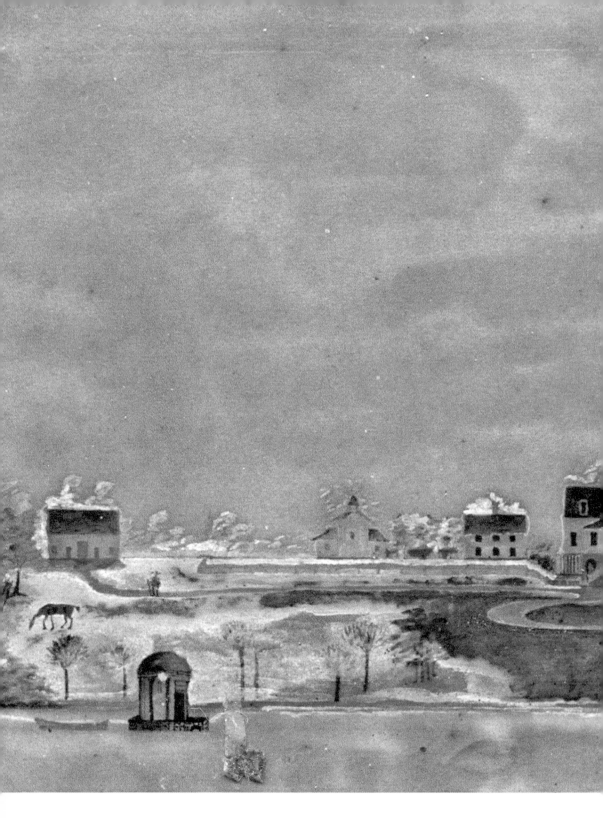

This watercolor depicts the Shoolbred Plantation, Kiawah Island. A member of the Drayton family rendered the painting about 1870. Notice the sense of order and place expressed here. *Courtesy of the Historic Charleston Foundation.*

banks of the Kiawah River, he developed the plantation according to techniques just beginning to be formalized by South Carolina planters. By the early nineteenth century, planters, overseers and slaves had developed an understanding of the fundamental principles upon which staple crop production could function in the environment of the Lowcountry. Planters articulately stated ideals for structuring rice and cotton production. Well-known memoranda written by William Butler and Robert Allston outlined the system for growing tidewater rice. Planters also circulated these ideals by word of mouth and in essays and letters in agricultural journals. The planters of St. Johns Colleton, Kiawah's parish, published the *Southern Agriculturist*. The ideals that Sea Island planters passed around to each other, tested and revised were frameworks for production that established a set of broadly understood and evolving principles for production. Lowcountry planters competed against one another for natural resources and profits. This competition was intensified on Kiawah Island, as the two planters attempted to establish their plantations on the same landscape, growing the same staple crop. The "New Settlement" was built close to the Vanderhorst plantation, on the northeastern part of the island. The Shoolbred plantation was an elaborate complex, replete with an elegant main house and several brick outbuildings. During the same period of time, Arnoldus Vanderhorst was in the process of rebuilding his Kiawah plantation. As both planters built up their holdings on the island, the pressures and tensions of locating and acquiring resources on Kiawah heightened. Tensions on the island also reflected the differences in mentality between the two planters. Structural differences between the two plantations gave evidence of differing sensibilities between the planters themselves.

Both planters built their Kiawah plantations hoping to take advantage of the cotton boom of the late 1790s. In turn, the planters established their households on the island. The best evidence of competition between the two households on the barrier island was a lawsuit, filed by James Shoolbred, that Vanderhorst's slaves fished on marshes that Shoolbred claimed to own. In the South Carolina Lowcountry, like the rest of the antebellum South, the household was a social and a spatial unit. The household was defined by the property to which the owner held title and over which he exercised exclusive rights. In a society in which land was the chief means of wealth, ownership of the land also incorporated claims over the dependents and laborers that relied upon the plot of land for their well being.

The two Kiawah households also included slaves in addition to the planters' families. The census of 1800 indicated the size of both the Shoolbred and Vanderhorst households. The census taker counted Vanderhorst and thirteen slaves as composing one household on Kiawah Island. The census taker counted Shoolbred, his wife and seven slaves on his Kiawah plantation. These numbers indicated that both plantations were under construction, while the Vanderhorst plantation was also in a state of transition from indigo to cotton production. A number of households in St. Johns Colleton owned more slaves. Approximately sixty parish households owned 1,546

slaves in 1800. Slaveholding on Edisto Island, a place where planters had already begun intense cotton production, was even greater, as a sample of thirty planters there contained over 900 slaves.

The antebellum Southern planter faced two main challenges: maintaining the health and increase of his slave labor force, and the successful production of agricultural products. The planter's responsibilities were enormous and his ability to meet them successfully determined the life and safety of those dependent on him and his own standing in the community. The planter often knew every detail of every agricultural operation conducted on the plantation. Furthermore, the planter looked on every natural and human-made feature of his property as a part of himself.

A few historians have written on the conflict between households that occurred during the antebellum period. Steven Hahn wrote about the disputes between yeomen households in Georgia. Hahn believes that these conflicts were inevitable because of the nature of the new market economy. In turn, these antagonisms served to absorb social conflict, establishing stability and standards for future social behavior. Stephanie McCurry has studied the effects of the conflicts between planters and yeomen farmers. According to McCurry, yeomen gained more political and social rights in their fights with planters. The yeomen gained the absolute right of mastery over their own households and the property that fell within its boundaries. The planter-yeomen conflicts forced the courts of South Carolina to define households. This legal definition benefited both classes.

Most useful to the discussion of the developments and disputes on Kiawah Island is Joyce Chaplin's interpretation of how planters had conflicts between themselves over parcels of land. With the advent of tidal rice cultivation after the Revolution, planters changed their perceptions of the Lowcountry landscape. The new method of cultivation set off a vigorous competition for natural resources between planters. According to Chaplin, these new methods of rice cultivation raised questions about old landholdings. Tidal rice cultivation was not possible on Kiawah because of a lack of a fresh water source, although it is possible that the new attitudes about land did influence the dispute between Shoolbred and Vanderhorst.

The origins of the lawsuit between James Shoolbred and Arnoldus Vanderhorst went back to the first English ownership of Kiawah Island. The original grant to George Raynor measured the island at 2,700 acres. This acreage only included the high ground of the island, and excluded marshland. In 1774, shortly after John Stanyarne's death, Henry Bonneau bought the marshes that surrounded Vanderhorst's property on Kiawah. Evidently, he turned over the title to Vanderhorst shortly after the transaction, as Bonneau did not appear on the 1775 partition and plat of the island. Vanderhorst now owned the marshes, creeks and oyster beds that surrounded Kiawah, as well as Sandy Point, the easternmost tip of the island. During the late eighteenth century, the extreme eastern point of Kiawah Island rapidly changed from marshland to a sandy beach.

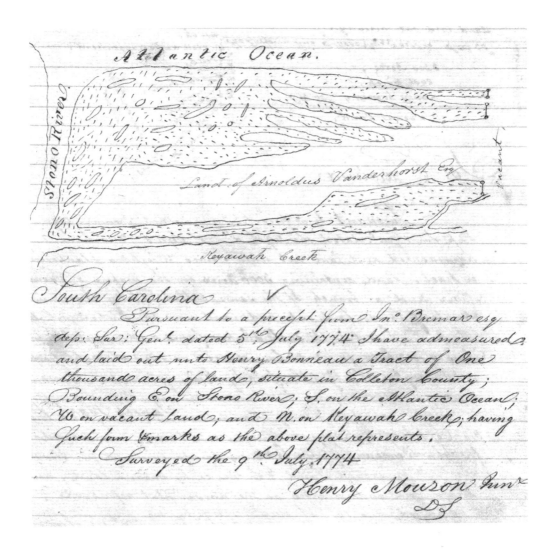

Henry Bonneau's July 1774 purchase of Kiawah marshes. Bonneau would turn this claim over to the Vanderhorsts shortly after the purchase. *Courtesy of the South Carolina Department of Archives and History.*

The conflict between the Shoolbred and Vanderhorst households dated back to at least to the summer of 1801. That summer, Shoolbred discovered his neighbor's slaves oystering in beds that Shoolbred claimed were his. The angry planter stormed down to the Kiawah River and cast the slaves' boats loose, stranding them in the marshes. Sometime after this incident Shoolbred filed a lawsuit against Vanderhorst, claiming that the oyster beds were his property. The extant court records only indicated when the suit was settled, not filed. The overseer's letters of October mentioned the dispute. Nicks informed Vanderhorst that "our neighbors seem to be…against our

Shell picking." Unfortunately for both planters, the suit dragged out for another year and a half. The Court of Common Pleas ruled that Vanderhorst owned the disputed oyster beds. As a result, Shoolbred had to pay court costs. The Kiawah planters did not use oyster beds for cotton production, but this land dispute signaled the fact that both planters had begun to allow the newer, cotton-dominated market economy to influence the ways in which they perceived their Kiawah estates. Both Shoolbred and Vanderhorst considered all parts of their plantations valuable. Every part of the estate contributed to the plantation economy.

In the South Carolina Lowcountry, as in the rest of the plantation South, the planters' vast landholdings included a variety of types of land, from cheap pine barrens to rich, expensive swamplands. On Kiawah Island alone, both planters owned rich, well-drained lands as well as parts of the island that were too sandy to plant, rendering them unsuited for cotton production. But the heart of the Shoolbred and Vanderhorst plantation settlements lay on the Kiawah River. The plat that accompanied the court papers defined three settlements on Kiawah Island. These settlements showed several buildings clustered together, situated around a main house. The three settlements were the Old Settlement (Stanyarne), New Settlement (Shoolbred) and the Vanderhorst Settlement.

The attempts by Shoolbred and Vanderhorst to master the Kiawah landscape can best be seen in two ways. Most importantly, both planters began to produce sea-island cotton on their Kiawah plantations. Sea-island cotton, a long-staple black-seed cotton, differed from the short-staple green-seed cotton that was cultivated widely throughout the inner coastal plains and the Piedmont of the southern states. Several types of black-seed cotton were grown in the South Carolina Lowcountry and each varied in yield, silkiness and staple length. Santee and Maines, for example, were grown on the mainland adjacent to the Sea Islands and were of moderate quality. The fine and superfine varieties of cotton, the types with the largest staple, earned the highest prices, and were considered the finest quality cotton in the world. These varieties grew only on the Sea Islands, dominated the Sea Island economy for over a century and provided the foundation for many large coastal plantations. Both Kiawah planters struggled to make cotton production profitable on the island. It is not possible to determine exactly how profitable cotton was to the Kiawah Island plantations, yet the question of profitability is important to establishing how successful the Kiawah planters were in mastering the island environment, their slaves and economic competition.

Both planters built plantations on the island to impose their own senses of order upon the island. These settlements exhibited a common social identity that in no small measure grew out of their particular location in the Sea Island landscape. The two planters had common goals. They sought to provide for their households and to acquire more wealth, yet they also seemed to have differing views of their Kiawah Island plantations. At the Shoolbred plantation, the planter maintained a tidy and well-

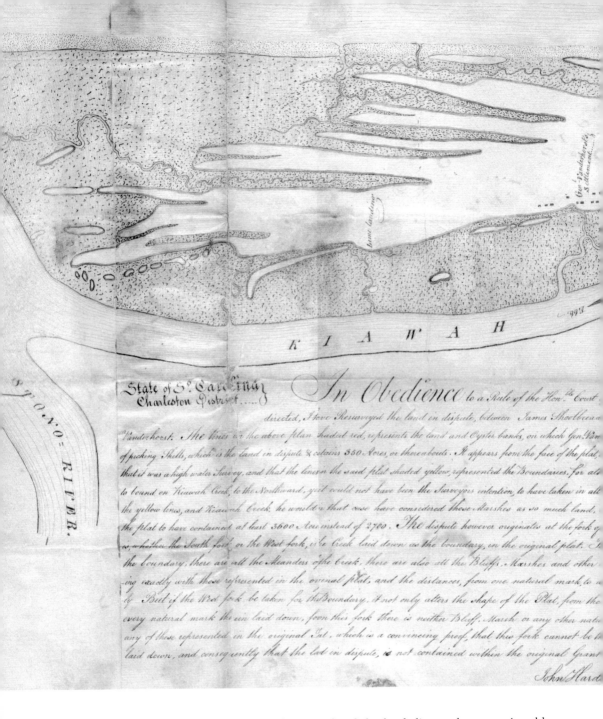

The 1803 plat of Kiawah Island, from the records of the land dispute between Arnoldus Vanderhorst II and James Shoolbred. Vanderhorst won. *Courtesy of the South Carolina Department of Archives and History.*

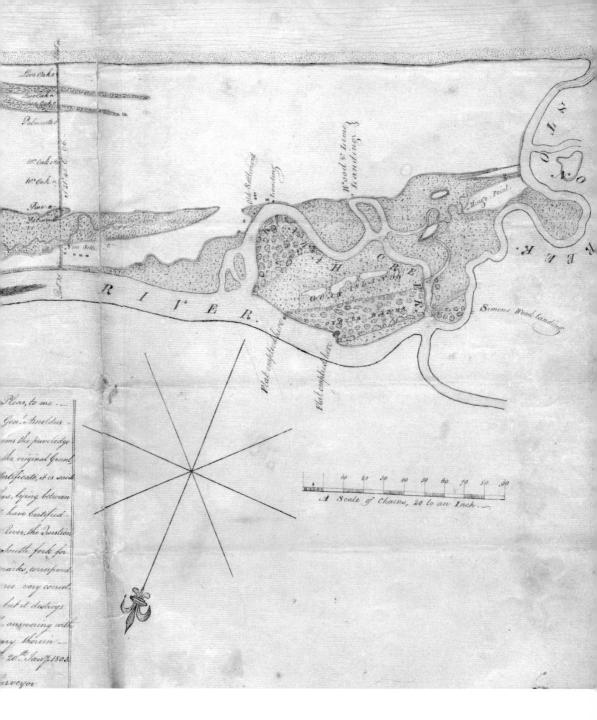

Live Oak's.

Live Oak's.

me Oak's.

Palmettos.

10. Oak or ...

10. Oak ...

Pine o.

Hickory o.

New Settl.t

Old Settlement

landing.

Wood & same
landing.

Mingo Point.

Simons Wood landing

RIVER.

THE CREEK

G O A T I S L A N D

Flat embked here

Flat embked here

CO...T

RIVER.

Pleas, to me

Gen.l Arnolds ...

...ms the purveledge

...the original Grant

...rtificate, it is said

...s. lying between

...have Certified

...River, the Question

...South fork for

...marks, correspond

...ree very correct

...but it destroys

...answering with

...ry therein

...20.th Jan.y 1803

...urveyor

A Scale of Chains, 20 to an Inch.

10 20 30 40 50 60 70 80 90

manicured landscape. The Shoolbred slaves worked diligently to control and harness nature. The yards surrounding the plantation were kept clean. Shoolbred did not dump his trash near the plantation; he either carted it away from the island or burned it. The landscaping indicated that Kiawah was the planter's vision of a "country estate." The buildings that made up the Shoolbred settlement were expensive and elaborate. The planter's mansion featured marble mantels, columns, supports and tiles. The use of carved brick, extensive plasterwork, wood moldings and a slate roof indicate the expense of construction. Surrounding the main house was a rather extensive network of support structures. A cotton storehouse, constructed of brick and roofed in slate, stood a few hundred yards from the mansion. Only the wealthiest of planters went to the trouble and expense of constructing a storage building for their crops. Because a storehouse held a valuable commodity, it had to be solidly constructed, and it had to provide adequate storage space. A house for the overseer stood near the cotton storehouse, as did a series of other buildings of unknown function. The Shoolbred slaves were housed at the Old Settlement, the site of the eighteenth-century Stanyarne plantation. This effectively put the field slaves out of view of the planter and his family, a few miles down the Kiawah River. The plantation was oriented to the river, possibly reflecting Shoolbred's view of the island landscape. The planter's view of the waterway to the mainland was perhaps symbolic of his belief that Kiawah's importance was in the island's accessibility by water, and not its isolation.

The Vanderhorst mansion stood atop an ancient dune ridge overlooking the Kiawah River, rising high above the surrounding marsh. The house contained four floors and an attic, featuring a timber frame resting upon a solid brick foundation. The house featured a simple construction and plan, compared with the more complicated designs of Charleston houses built during the 1790s and 1800s. The Vanderhorst plantation featured makeshift buildings, such as a kitchen that stood even after the planned structures were finished. Vanderhorst scattered his slave quarters in cheap, makeshift housing directly behind his own mansion. Vanderhorst also had his garbage dumped in the marshes on his plantation, instead of having it carted away. Furthermore, the Vanderhorst mansion faced the beach, not the river, suggesting a different concept of place from that of the neighboring Shoolbreds.

Shoolbred's house faced the river, possibly reflecting a more pronounced orientation toward communication and trade with various places in the Lowcountry. Vanderhorst might have had a more limited perspective regarding his Kiawah plantation. The rustic, simple design of the plantation house reflected a less rigid view of place. Vanderhorst seemed to emphasize the importance of the economic activities on his Kiawah plantation. Whereas most Sea Island planters, like the neighboring Shoolbreds, built outbuildings and cultivated gardens and yards around the plantation, Vanderhorst added little to the plantation settlement. Vanderhorst might have believed that the beauty of his island plantation was not something that he could create or buy, but the appeal was in the place's natural beauty. This belief might also have affected agriculture production on the

island, as it was certainly possible that the differences in the plantation settlements might reflect the difference of wealth between the two households. These two plantations, both operating on a relatively isolated Sea Island in the nineteenth century, reveal how the planter's vision of his plantation had material consequences. Shoolbred's mentality was different from Vanderhorst's, explaining the material and spatial differences between the two plantations. During a summer in the early 1820s, Ann Vanderhorst, Arnoldus's daughter-in-law, dined with Shoolbred. She also gave her opinion of her neighbor: "I am delighted with the old gentleman, he is elegant in his manners as most men who have seen much of the world are, and combining this with a highly improved mind."

South Carolina Sea Island planters grew cotton on old indigo lands. By 1800, planters and their slaves established a general set of guidelines for developing productive sea-island cotton plantations, though their methods for growing a quality fiber continued to evolve and, like techniques for growing indigo, adapted to local circumstances. Sea-island cotton grew in a wide range of conditions. The most valuable and silkiest cotton was produced in environmental conditions found only on the Sea Islands. There, the moisture-laden winds made the staple longer, silkier and glossier. Planters also credited the saline quality of the soil with improving the staple.

The grading of cotton crops marked the point at which the market explicitly intruded into the agricultural regimen. The market demanded cotton grades, but the grades also reflected the social commitments of coastal South Carolina planters. The planters took great pride in a high-quality staple and put their names on the bales of the best cotton. Once a planter established a reputation for quality, cotton stamped with his name commanded a high price. Cotton grades were an index of social and economic reputation. It is difficult to determine what kind of reputation Kiawah cotton, and in turn the planters, had in the early nineteenth century. Arnoldus Vanderhorst II died in 1815, leaving his Kiawah plantation to his son Elias. A Charleston merchant sold part of Vanderhorst's Kiawah Island cotton crop of 1838, amounting to nine bales, for almost $1,000. Two years later, Elias Vanderhorst sold twenty-two bales of Kiawah sea-island cotton for almost $1,300. These prices and amounts might represent the declining quality of the cotton itself, or it might indicate declining prices for the staple.

The advent of the sea-island cotton industry brought many changes to Kiawah Island. The Kiawah planters realized that every part of their plantations could be used in order to be competitive in the new cotton-based economy. Yet both Shoolbred and Vanderhorst had different perceptions about the importance of place on their Kiawah plantations. The differences in the physical makeup of the plantations revealed the varying wealth on the island. The difficulties and uncertainties of producing a new commodity added to the tensions on the Kiawah landscape.

In January 1824, Lewis Morris, Elias Vanderhorst's brother-in-law, spent time on Kiawah, "walking on the sea beach, feasting upon fish and game, and occasionally paying

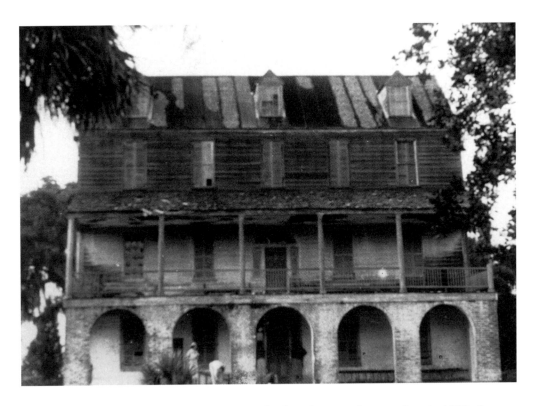

The Vanderhorst plantation on Kiawah Island. This photograph was taken in 1937. *Courtesy of the Charleston Museum.*

morning visits to Mr. Shoolbred and his daughter Miss Eleanora." A small portion of James Shoolbred's papers have survived; they are owned today by the Charleston Library Society. Unfortunately, none of the surviving Shoolbred manuscripts has anything to do with activities on Kiawah Island. Mary Gibbes Middleton Shoolbred died in July 1808 at the age of thirty-two. Shoolbred outlived his wife by almost forty years, dying at age seventy-one in September 1847. They were both buried on Kiawah, very close to the site of their old house.

There became three landowners on Kiawah Island after James Shoolbred's death. Mary Shoolbred Drayton, his daughter, acquired the central portion of the island, as well as the Shoolbred plantation complex on the Kiawah River. Ann Shoolbred Burrill had died, so her four children living in New York acquired the western portion of the island. The Burrills did get the old Stanyarne plantation on the river. The Drayton plantation, under the control of Mary's son Thomas, produced fourteen bales of cotton and a handful of provisional crops in 1850. At Mary Shoolbred Drayton's death in 1855, the plantation passed to her two sons Thomas and John Drayton. The plantation was still large, with cattle, tools, horses and seventy-five slaves. The brothers owned the place until January 1860, when they sold it to Isaac Wilson.

The census of 1860 records fewer slaves living on the Wilson plantation. Cotton production actually increased over the 1850 numbers. The plantation produced twenty bales of cotton. Yet production of subsistence crops declined. Maybe Wilson wanted his Kiawah plantation to produce more of a staple crop and have his other plantations supply it with provisions. It is not possible to know what was happening on the Burrill tract in the 1850s. After owning the plantation for several years, the family sold the property in March 1854 to William Seabrook.

On the eastern half of the island, Elias Vanderhorst and his slaves continued to plant Kiawah every year, so they were susceptible to the boom and bust cycle of the sea-island cotton market. The middle of the 1830s was apparently a profitable period, as Elias wrote to his wife Ann, "I have sent the sloop down with my great crop of cotton. You will receive vegetables, strawberries." The following decade was more difficult. The island was extremely dry during the spring of 1841, and Elias sardonically wrote, "Everything goes wrong here." The following summer the Kiawah sea-island cotton crop was ruined, "nearly destroyed by water." A telling indication of the island's struggles was the size of the slave population. In 1820, there were 120 slaves on Kiawah; by 1840 there were 46.

In September 1852 Elias Vanderhorst reported from Kiawah, "The weather here is very bad, it has been raining almost incessantly. What is to become of the planters I do not know." Sea-island cotton production dropped off considerably in the 1850s, from 2,500 pounds in 1854 to 600 in 1860. Again, staple crop production on Kiawah was hit-or-miss throughout the late antebellum decades.

There are glimpses of slave life on Kiawah Island during the 1850s. Ann Vanderhorst witnessed "the Kiawah maidens [slave women] in high frolic—they danced by the light of the moon and Master [Elias] was pleased they were so happy. Sunday morning they presented themselves to me." Bailey was the slave driver, managing the island's daily activities. The food allowance for each adult was six pounds of vegetables and a peck of cornmeal per week. The Vanderhorsts expected the slaves to shoot or catch meat and fish. Forty-two slaves lived on Vanderhorst plantation in 1860. There were eleven men, eighteen women and thirteen children.

Adele Allston was a member of one of the most wealthy and prominent planter families of the South Carolina Lowcountry. Her family owned hundreds of slaves who built and maintained profitable rice plantations. During the Civil War, she married into the Vanderhorst family. A few of Adele's diaries survive. In one dating from the late 1860s, she asked a strong rhetorical question related to the landscape of Kiawah Island: "Now since that desolating Civil War of 1860 where is the grand mansion of Mr. Shoolbred—the noble house of the Vanderhorsts[?]" The diarist proceeded to answer her own question, as the mansions on Kiawah have been "cut up and chiseled, the squares thrown far on the Sand and Desolation stalks the Land." Adele also noted that after the war, as the Vanderhorsts returned to the island to evaluate their losses, they "looked around in vain for the marble mantelpieces all torn down from their mooring." The bitterness and

Mary Middleton Shoolbred, James's wife. She was buried on Kiawah when she died in 1808. *Mrs. James Shoolbred (Mary Middleton)* by Jean Francois De la Vallee, watercolor on ivory. *Courtesy of the Gibbes Museum of Art/Carolina Art Association.*

helplessness is evident in Adele's passage. The Southern planter class suffered greatly during and after the Civil War. But so did their sense of place, their sense that they dominated a small area of the world.

In the winter of 1861–62 a detachment of the Seventeenth South Carolina Regiment went to Kiawah Island searching for supplies. Samuel Catawba Lowry and a handful of other Confederate soldiers traveled on "a little road, just wide enough for the wagons to pass through, with a jungle on each side of the palmettoes and other lowcountry vegetation so thick that you cannot see five steps into it." The soldiers eventually rode onto the Vanderhorst plantation, "where we found several negroes, the only persons on the island." The slaves sold chickens, eggs and lambs to the Confederates. Lowry and the other soldiers didn't leave Kiawah until they went to the beach, where they swam and collected shells. One of the officers, Captain Walpole, "discovered a footprint freshly made in the sand, and knowing it to be one of our enemies," the soldiers left the island and returned to camp on Johns Island.

As the war began in the spring of 1861, Kiawah Island's economic and social landscape changed drastically. Lowry's account highlighted the transformation from antebellum ideals to the difficulty of taming the Sea Island environment during Reconstruction. Lowry's account also exhibited the perception of Kiawah's value to soldiers and civilians. Kiawah Island was isolated geographically and seemed removed from the fighting. However, the small group of Confederates did find evidence that Federal soldiers shadowed them on the island. The few people that lived on the island were slaves. Because of the economic and military situation brought on by the war, many questions emerged: How should the slaves react? Were they still owned by the Vanderhorsts, Wilsons or Seabrooks? Should they grow cotton and provisions? Should they leave the island and search for family, friends and safety?

THE CIVIL WAR AND ITS AFTERMATH ON KIAWAH ISLAND 1861–1881

Early in the morning of April 12, 1861, Confederate batteries opened fire on Federal troops inside Fort Sumter in Charleston Harbor, starting the American Civil War. All who were living and working on Kiawah that morning could clearly hear the barrage. For the next four years, military action in the Lowcountry centered on the city of Charleston. But to the Vanderhorst, Wilson and Seabrook plantations on the island, the war came early and often. Afraid of depredations from Federal and Confederate troops, the Vanderhorst slaves moved from Kiawah to the family's Ashepoo River plantation. During the American Revolution, Kiawah Island was perceived to be a safe haven for planters, slaves and soldiers. That perception changed during the Civil War. The better equipped and manned naval ships of the Federal blockade and the determination to capture Charleston contributed to the idea that property on Kiawah was vulnerable to attack.

Arnoldus Vanderhorst IV joined the Confederate service and saw combat as a member of General William Whiting's division. In June 1863, Arnoldus returned to Charleston to wed Adele Allston, a member of another large planter family. The wedding took place in the Vanderhorst's town house at 28 Chapel Street. Many of Charleston's old families attended the ceremony, undoubtedly being a respite during the long, grueling Federal siege of the city.

In March 1862 the Confederate commander of forces in defense of Charleston, General John C. Pemberton, ordered the withdrawal of Southern troops from the Sea Islands south of the city. He was concerned that the Confederates did not have enough men and supplies to defend this region of the Lowcountry. The following month, the Third

Civil War scenes on Kiawah Island, 1863. *Courtesy of* Harper's Weekly.

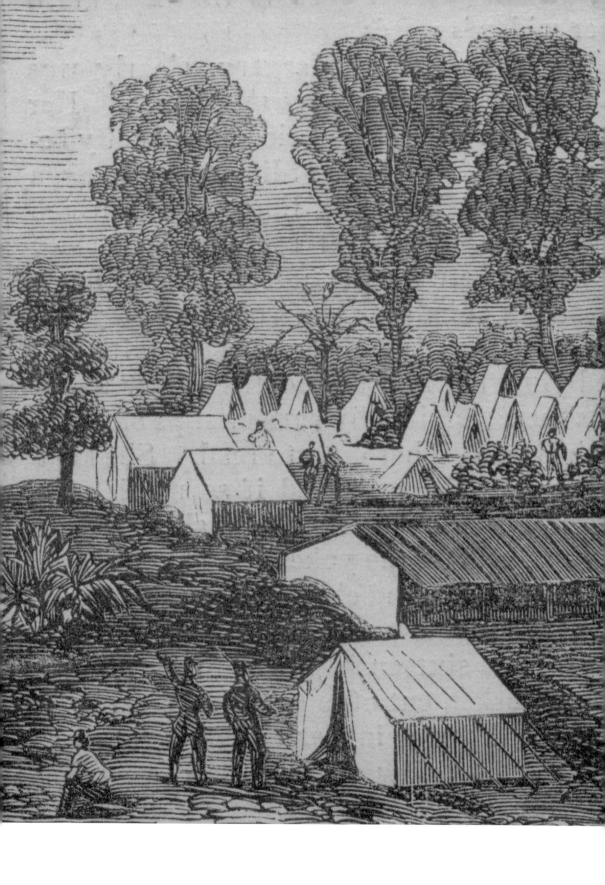

New Hampshire Infantry made a short reconnaissance mission to Seabrook and Kiawah Islands. These troops gauged Confederate strength on the outer islands and looked for possible staging areas for attacks on Charleston.

Kiawah played a minor role in the Federal siege of Charleston, which began in the spring of 1863. General Quincy Gillmore directed the siege, using the Sea Islands around the city as staging areas where Northern troops could re-supply and launch attacks. By the summer of 1863, Federal soldiers had established strongholds on Folly and Morris Islands, just north of Kiawah. Union troops held a weak line along Seabrook, Kiawah, Folly and Morris Islands, but they still faced the difficulty of taking Charleston itself. In early September 1863, Federal troops on Kiawah were ordered to "reconnoiter Kiawah Island thoroughly." "By frequent patrols of the island," the soldiers would prevent "the erection of batteries by the rebels." Clearly, in the fall of 1863, Kiawah Island was the scene of skirmishes between the opposing armies. At the end of September, Federal troops built rifle pits and a boat landing on the eastern end of the island. Northern soldiers also built two makeshift forts on the island, one located close to the beach. At least one skirmish between Federal and Confederate troops occurred in late 1863. In late October, a Union battery on the western end of the island, near Seabrook, engaged Southern troops across the Kiawah River.

As 1864 opened, Federal forces used Kiawah as a staging area. These units keyed upon harassing Confederate posts on Johns and James Islands. In February the 41st New York, 54th New York, 142nd New York and 74th Pennsylvania Regiments landed on the island, then crossed over the Kiawah River to engage Southern troops on Johns Island. This force, numbering about a thousand men, gauged Southern strength south of Charleston. A couple of months later, more Federal troops were dispatched to Kiawah, undertaking additional forays onto the adjacent islands. A Northern officer wrote in May, "I very much need facilities for mounting a small force of infantry for the purpose of patrolling the whole of Folly Island and also Kiawah."

Small detachments of Confederate troops harassed the enemy on the islands south of Charleston during 1864. Southern troops also continued to forage on Kiawah even though Federal troops were a constant presence on the island. A Confederate officer named Captain Parker wrote to Elias Vanderhorst in June alerting Elias to his having "ordered a Scouting party over to Kiawah with a view of ascertaining the location of the Yankees and of bringing off some Stock said to be there." As the city of Charleston hung on grimly in the summer of 1864, both sides were still using Kiawah Island on a frequent basis. By the fall of 1864, with Sherman's army approaching coastal Georgia and South Carolina, Federal attempts to take Charleston had subsided. The end of the siege, and the war, was near.

With thousands of soldiers and sailors from both sides occupying Kiawah, how did the plantation households on the island fare? A few glimpses survive. During the first week of March 1862, Arnoldus Vanderhorst IV visited the island. He found his family's

plantation to be in fairly good shape. The old Shoolbred plantation, now owned by Isaac Wilson, was not so fortunate. Arnoldus described how Confederate troops "had broken into the fine dwelling house and maliciously destroyed the furniture, and left the house in such a condition that it scarcely ever will be habitable for a decent family." The Southern soldiers also robbed a slave who was left on the Wilson plantation as a caretaker. They stole most of his chickens, rifled through his house and "stole a new pair of shoes that his master had given him." Why Confederate troops ransacked the Wilson place and left the Vanderhorsts alone is unknown. It is possible that the Vanderhorst slaves placated the soldiers by trading with them, or maybe the marauding Confederates knew the Vanderhorst family. Whatever the reasons, there was certainly an effort on the part of both armies to acquire supplies on Kiawah and to use the island as a buffer zone between the two armies. Predictably, plantation agriculture suffered badly in this environment.

In December 1863 the Fifty-fifth Massachusetts Volunteers, a labor detachment recruited from free African Americans in the North and freed slaves from South Carolina, was ordered to construct a signal tower on Kiawah Island. The soldiers built the tower on the far eastern end of the island, near Folly. They probably bivouacked close to the Vanderhorst plantation. On the wall of the Vanderhorst mansion one of the Federal soldiers wrote "55th Regt Mass Vol.Inf." On an opposite wall of the house soldiers wrote, "How are you Genl. Beauregarde" and "Veritas vincit." (The Latin translates to "truth triumphs.") Apparently a member of the Seventy-fourth Pennsylvania wrote on the walls as well, as "How are you Johnny Rebel, 74th Regt."

Military activities on Kiawah Island during the Civil War destroyed the plantation order on all three of the island's estates. The plantations were no longer isolated, as both armies turned the island into hostile territory. War eroded the vital relationships between masters and slaves and disrupted routine. Generally, slavery broke down gradually throughout the plantation South. However, slavery ended on Kiawah in a fairly sudden manner. Elias Vanderhorst sent his strongest and hardest working slaves to his plantation on the Ashepoo River early in the war. The handful of slaves left on the island were either too old or young for strenuous labor. On May 5, 1864, a detachment of about a hundred Federal soldiers patrolled Kiawah. Arriving at the only working plantation on the island, the bluecoats encountered "the negroes at Vanderhorst's plantation (8, old and young)." The Union officer making the report described emancipation succinctly: "They were allowed to move within our lines, where they are now established." On June 1, another Union scouting party visited the plantation. The former slave Frank "will be allowed to bring in any of his stuff or cattle still on the Vanderhorst plantation."

Another development that affected Kiawah Island in the last several months of the Civil War was General Sherman's famous Special Field Order Number 15, issued in January 1865. The order set aside the "islands from Charleston south" for exclusive settlement by freed slaves. The Federal government considered most of this land to be abandoned by

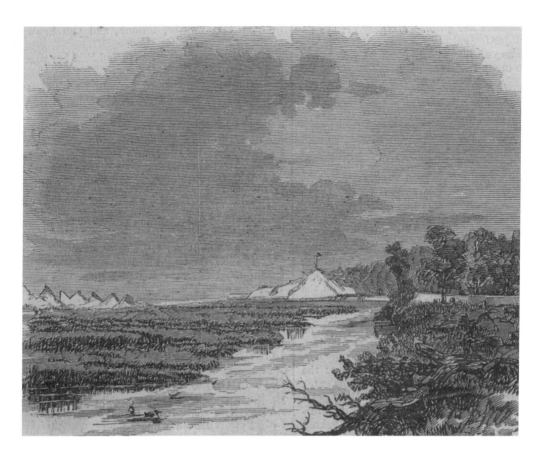

Kiawah Island, August 1863. *Courtesy of* Harper's Weekly.

its owners, mostly Southern planters. By the summer of 1865 African American families settled all over Edisto, Wadmalaw, James, Johns and Kiawah Islands. A careful student of the subject has estimated that about forty thousand blacks settled on coastal South Carolina lands as a result of Sherman's order.

As the summer turned to fall, Federal policy in regards to the Sea Island lands changed. A new policy, drafted by President Andrew Johnson and his advisers and issued in September as Howard's Circular Number 15, ordered the lands to be restored to their previous owners. The owners had to have been pardoned by the United States government. Elias Vanderhorst responded quickly to the new policy. On September 6, 1865, Elias took a loyalty oath to the United States Constitution and also swore to support the emancipation of slaves. A little over two weeks later, on September 22, Elias received permission from Federal authorities to visit his plantation on Kiawah. After the visit, Elias wrote to his son Arnoldus IV, "We have lost everything in the country [Kiawah plantation], not an article saved, not even your mare and colt and the people [slaves] scattered. We are very well but in poverty as you may suppose." In November, Elias

petitioned the Federal authorities to have "my plantation in the Eastern end of Kiawah Island restored to me. This tract of land has been in my possession since the year 1815, by inheritance."

Elias Vanderhorst visited Kiawah again in November 1865 with a group of several men, one of whom was a naval officer. Vanderhorst and his party counted twelve black households, however not all of the blacks had been slaves on the island. Vanderhorst questioned several of the freed blacks "and those who were strangers on the island did not hesitate to acknowledge it." Elias was desperate to have anyone working on the island. He allayed the blacks' fear by telling them that he would let them live and work on Kiawah.

Cotton production occurred on Kiawah during the later years of the war, so the notion that the abolishment of slavery ended staple crop agriculture was certainly not so. Production lessened, but did not drop off. In January 1865, the Vanderhorsts sold three bales of cotton to a London factor. In September, probably from a freshly grown crop, another two bales were sold. Who labored to produce the late 1864–early 1865 crop is unknown; Elias could have sent some slaves from Ashepoo to Kiawah late in the war, or maybe a freed slave community had already emerged on the isolated Sea Island. Elias's visits in the fall of 1865 may have been spurred by his enthusiasm for the Kiawah plantation in attracting freed black labor.

Attracting freed blacks to Kiawah Island was not a problem; the difficulty for the Vanderhorsts was trying to get the freed slaves to work in ways similar to slavery. There is a fragment in the Vanderhorst papers that contains an order from the Freedman's Bureau office in Charleston. It is Circular Number 2, issued on January 24, 1866, and it claimed that many freed slaves were moving from the interior of South Carolina to the coastal region with "no definite object in view." According to the order, the Freedman's Bureau would only furnish transportation to ex-slaves "who have entered into contracts, and are going to the plantations or localities where they have contracted to labor." Among the Southern planter class, the great concern immediately after the war was, Will the freed blacks work?

Most observers, North and South, believed that the ex-slaves would never be able to compete as free labor in the United States. It was believed that the ex-slaves did not have the self-discipline or skills to find and maintain employment. Planters also understood that as long as they controlled land ownership, they controlled black labor in the rural South. The freed slaves desperately wanted to acquire land, as they equated owning land with self-reliance and liberty. Kiawah Island planter Arnoldus Vanderhorst IV, like many Southern planters, reestablished authority over his laborers' lives by signing a labor agreement with the ex-slaves. On March 22, 1866, sixteen black men signed an agreement to work and live on the Vanderhorst's Kiawah plantation. Compared to labor contracts in other parts of the South, this labor contract seems to be generous to the freedmen. The blacks living on the plantation agreed to "abide cheerfully by all laws governing this United States," "to cultivate this land in a workman like manner" and to divide the cotton crop "evenly among the freedmen."

The following year Arnoldus Vanderhorst IV and the ex-slaves signed another labor agreement. There is a striking difference with the second contract. There were twenty names on the contract, twelve men and eight women. Compensation was spelled out for the male laborers. The blacks were to be paid one hundred dollars for one year of labor, they were to be provisioned with bacon, salt and corn, and Vanderhorst was to provide them with clothes. The female laborers were to receive sixty dollars for one year of labor. There were about seven black households on the Vanderhorst plantation in the early years of Reconstruction. These blacks were probably Kiawah slaves. In the plantation book of the 1850s, there is a mention of a slave named John Rose, possibly related to the Rose family on the contract. The slave Shorum is probably Shorum Preston, Little Lunah is probably Lunah Smith and Scipio is probably Scipio Smith.

To keep up his end of the bargain, Arnoldus Vanderhorst IV supplied the Kiawah plantation throughout Reconstruction. In March 1867, the planter sent twenty-five sacks of corn, bacon shoulders and barrels of molasses, salt and flour to Kiawah. In August, pork, sugar, soap and hardtack showed up at Kiawah, along with clothing for the freedmen and a few farming implements. Vanderhorst must have discouraged the production of provisions on the plantation and expected that the ex-slaves attempt to produce sea-island cotton. Furthermore, his practice of sending extensive provisions to the freed slaves allowed him a certain amount of control. The Kiawah laborers insisted that along with the risks of farming they should be able to make more decisions on the plantation. Vanderhorst believed only he could make judgments about the plantation.

In the spring of 1867, Arnoldus Vanderhorst consigned 3,800 pounds of sea-island cotton from Kiawah to his factor. While down from 1850s production, this crop was an excellent yield. The Vanderhorsts and their black laborers hoped that this upward trend would continue. Obviously the freedmen were working very hard. The Vanderhorsts felt optimistic about the post-bellum prospects for the Kiawah plantation. One of the family friends remarked to Ann Vanderhorst in January 1868 that she had heard from a reliable source that "Arnoldus has made still more [money] both this year and the last at Ashepoo and Kiawah." The friend also reported that Elias "has made much more at his wharf."

During Reconstruction, planters lost economic and social power in the South. Many planters tried to get away from the agriculturally based economy and diversify (some would say modernize) their business interests and capital. The Vanderhorsts continued to develop interests at the wharf on the Cooper River, but they did not abandon ideas that Kiawah could be a profitable cotton plantation. In 1867, twenty-three bags of sea-island cotton were shipped from Kiawah. The following year thirty-one bags were shipped, then in 1869 only ten bags. By 1870, Arnoldus's Kiawah papers mention pockets of cotton shipped, this lesser unit measurement reflecting smaller production on Kiawah. Provisional crops were also sold from the Kiawah plantation, and these sales must have allowed the Kiawah laborers and the Vanderhorsts to stay fairly optimistic.

Throughout the 1870s, it is likely that the blacks working on Kiawah were producing a few bags of sea-island cotton per year. The problem was that the price of cotton dropped

steadily. For example, in 1872 net proceeds from two bags of Kiawah cotton came to $360. Ten years later, the Vanderhorsts gained a profit of $166 from two bags of cotton.

Outside of the Vanderhorst plantation, ownership of the rest of Kiawah Island proved to be dynamic during the later decades of the nineteenth century. In 1866, Isaac Wilson had to sell his half of the old Shoolbred tract because of debts. James Gibbes, who was a cousin of Thomas and John Drayton, purchased the land for $4,510. Six years earlier the Draytons had sold the tract to Wilson. Gibbes's intent was clearly to keep the plantation within his family. When Amelia Gibbes, James's daughter, married John Haile, a contract stated that the Kiawah property would pass from Amelia to her children. If the children died prematurely, the plantation would revert back to James Gibbes or his estate. The other half of the old Shoolbred plantation changed hands as well. Sometime in the late 1860s or early 1870s, William Seabrook stopped owning the property and William Gregg acquired the plantation. There are strangely no records that survive to reveal the nature of this conveyance. In 1872, Gregg sold the land to H.H. Hickman for $1,850. Seven years later, Arnoldus Vanderhorst purchased the tract from Hickman for $750. In 1879, the Vanderhorsts owned all of Kiawah, except for the central quarter owned by the Gibbes. Elias Vanderhorst died in 1874, passing ownership of his Kiawah plantation on to his son, Arnoldus Vanderhorst IV.

The Vanderhorsts have left some interesting impressions of life on Kiawah during the 1870s. The family continued to live for most of the year on Chapel Street, yet they would come out to the island to fish, swim, hunt and also to oversee activities. In the summer of 1870 Arnoldus wrote to his wife Adele that everything was fine on the island. Arnoldus had another "beach shanty" built on the eastern end of the island and he was sleeping there. Ann Vanderhorst, Arnoldus's mother, struck a much more serious tone. She was clearly fed up with the Grant administration's Reconstruction policy. She wrote that President Grant was a "vindictive persecutor of us poor people. We have no friend but the Great God above us." The Southern planter class had lost much, and the end of the struggle seemed to be very far off.

The Sea Island landscape posed difficulties to the laborers and the Vanderhorsts in the 1870s. Writing in the summer of 1872, Arnoldus reported that the Sea Islands were suffering through "a serious drought, which injured my crop to a considerable extent. The cattle were dying on Kiawah for want of pure water." The Kiawah landscape, though tough to manage, was always beautiful. Adele and the family were enjoying the beach, "also the bathing." She wrote that during the summer of 1874 "there has been a great deal of rain with frequent storms of wind." Adele was also the author of a wonderful entry in her journal, describing Kiawah's beauty and tradition. She wrote, "The island of Kiawah, here are tracts of gigantic old oaks…while the graceful Jessamine creeps over the tree tops, perfuming the air." She also mentioned "the dense thickets, where roam the Red Deer and the wild turkey." Adele was also proud of the family she had married into, because "some 100 years ago this island has been handed down to the descendants of the Vanderhorsts and [then] to the present owner Arnoldus Vanderhorst." An entry of May

James Gibbes was one of several men who owned land on Kiawah Island in the late nineteenth century. *James Shoolbred Gibbes* (1819–1888) by unknown artist, enamel on porcelain. *Courtesy of the Gibbes Museum of Art/Carolina Art Association.*

23, 1876, related how "the Lord of the manor [Adele's husband, Arnoldus] administers to the necessities of the negroes, the operators who lost their crop by the Drought last summer." It was difficult for both races to adapt agriculture to the demands of climate and the market on the South Carolina Sea Islands during the 1870s.

One of the interesting artifacts of Kiawah's history is a watercolor executed sometime in the early 1870s. The painting is supposed to be a depiction of the Shoolbred plantation, most certainly drawn from memory. The faded painting shows an elegant house with a series of surrounding outbuildings. A small gazebo stands at the river's edge, and formal gardens can be seen between the main house and the river.

An era ended on Kiawah Island the first week of December 1881. Arnoldus Vanderhorst IV, Quash Stevens, Ephraim Seabrook, William Andell and a man named Legare were hunting on the island. On the morning of December 1, the party hoped to drive some of the deer toward Andell's deer stand. Satisfied that the dogs were doing an effective job driving the deer, Arnoldus rode off from Andell's position to reach a stand of his own. About twenty minutes later, Quash reported that he heard a shot fired away from the direction of the hunters, but he ignored it. About an hour later, Seabrook and Andell changed plans for the hunt and went to find Arnoldus. They found his horse tied to a tree, but they did not see Vanderhorst. At one o'clock, the deer escaped to a marsh island, a hunter sounded the horn for assembly, and the hunt ended. Arnoldus was still missing, and the men returned to the place where his horse stood. A search started for him throughout the surrounding woods. Arnoldus was found about five o'clock, lying on his left side. His double-barrel shotgun was by his body, the right-hand barrel empty. Arnoldus had been shot in the head. At midnight, Arnoldus's friends and family took him by boat to Charleston. They arrived at Vanderhorst's wharf in town the next morning. The coroner called an inquest that afternoon. The inquest ruled that Arnoldus, while stepping over a log, placed his shotgun, stock downward, in front of him. This action caused the gun to discharge, causing an instantaneous death. All of his property went to his wife Adele Allston Vanderhorst. And a younger generation, a generation born after the Civil War, unaccustomed to owning slaves and large plantations, got closer to owning large Lowcountry plantations.

7.

Kiawah Island and the New South 1882–1915

There was not much to be excited about on Kiawah Island in the late nineteenth century. The island was under the ownership of Adele Allston Vanderhorst, but the property was actually managed by a series of men with different personalities and goals. One of the best managers was Quash Stevens, one of the more interesting people ever associated with Kiawah. Born in the early 1840s, Quash was the son of Elias Vanderhorst and a slave woman. After the death of his half-brother, Arnoldus Vanderhorst IV, Quash became the man who controlled activities on Kiawah. In the early 1880s, Quash was married to Julia and had four children: Eliza, William, Annie and Laura. In the spring of 1883, Quash reported to Adele about life on Kiawah. Julia Stevens was still sick "and yet over her Troble [*sic*]." He observed that the weather had been rather cool, and the cotton "Crop Look Badely." Quash's love for his Vanderhorst family was evident in his letters. Also, Quash's letters revealed a love for Kiawah, as well as his desire to extract a good living from his work on the plantation.

A letter written in April 1900 by Julia Blake, a cousin of Adele Vanderhorst who was staying on Kiawah, noted that Quash was "still the Cassique of Kiawah, in the absence of the owners." Miss Blake observed that Quash was getting old, yet he was still working hard on the island. He was about sixty years old in 1900. This former slave and member of the Vanderhorst family clearly controlled the island during his tenure there. Adele Vanderhorst owned the land and depended on Quash Stevens to manage the plantation.

Quash's letters revealed the farming activities on Kiawah in the last two decades of the nineteenth century. He reported in the fall of 1886, "I made the best Crop of Potaito Peais Corn I Have avr made." Livestock raising was a major activity on Kiawah in this era as well. Quash was continually sending cattle to market, as well as sending

eggs, cream and butter to the Vanderhorsts on Chapel Street. There were occasional references to cotton, so production of the Sea Island staple continued. But it is possible that Quash and the other farmers on Kiawah reduced their planting of sea-island cotton and focused their energies on more diverse, profitable farming activities. A June 1883 letter pointed toward other lucrative possibilities on Kiawah. Quash wrote that he had to prepare five rafts of palmetto logs for shipment. This would be hard work because "the Logs is ver much scaterd so I Hav to Hall Them."

The black tenants on Kiawah Island faced difficult challenges as they tried to harness the potential of the Sea Island landscape. There were years that little rain fell. Quash lamented in the fall of 1887, "We have not Had aney raine for Nearly 2 moints." Several years later it rained too much. It rained on Kiawah every day for a month in the summer of 1894. Much of the land was under water, but Quash reported that the cattle were doing very well. During the night of August 27, 1893, one of the worst hurricanes ever slammed into coastal South Carolina. Witnesses reported a storm tide of almost twenty feet. Quash wrote that the "Tide Caime owpe in my House" and "9 House on the Plaise is Woish Don." Virtually all of the crops were lost in the storm, as the entire island was under water from two to eight feet. Acquiring fresh water became very difficult, and Quash and many of the blacks on Kiawah had gotten sick. Quash's frustration is easily discernible in his letters to Adele.

In October 1895, Quash wrote Kiawah's owner, Adele Vanderhorst, wishing to talk about the state of affairs on the island. He declared, "I Will Doo all I Can to make it Pay you as Well as myself." The overseer was definitely making money off of his agricultural ventures on Kiawah. Yet Quash seemed to have larger plans for the island. He told Adele that he had someone ask him what Kiawah was worth. Quash was confident that the Vanderhorsts would turn to him first, stating "if aney one woint the Place you Wood gave me Preffreince [sic]." He concluded the letter by saying that he had not mentioned his intent to anyone. It is not clear if Quash intended to buy a portion of the island, or if he is referring to some lease arrangement. He definitely aspired to own his own land, and having worked on Kiawah for over thirty years, felt very comfortable with its output and possibilities.

In March 1896, Quash Stevens and Adele Vanderhorst signed a contract allowing Quash to lease Kiawah for three years. He paid $400 the first year and $500 the remaining two years. Sometime in the late 1890s, for reasons that remain unclear, Quash became dissatisfied with the situation on Kiawah Island. Quash signed a lease agreement with Adele for one year, dating from January 1900. Twice in the spring of 1900 Adele Vanderhorst loaned Quash Stevens $150. On November 10, 1900, Adele's twenty-three-year-old son Arnoldus V wrote the black overseer and stated that he knew that Quash was "making preparations to leave." Furthermore, Quash was not to take any cattle or sheep "without my concurrence." The young Arnoldus V apparently had Quash's successor already picked out. He remarked to Quash, "Simon Boggs is in my employ and any interference with his duties cannot be tolerated."

Some writers have suggested that Quash Stevens left Kiawah because Arnoldus Vanderhorst V had treated him poorly. The reason might be simpler than that. Quash Stevens became a member of a growing black middle class that emerged in the South in the few decades before World War I. Many of the blacks who bought land in the post-Reconstruction South received credit from black-owned banks. Quash got his money from production on Kiawah and borrowing from Adele Vanderhorst. The increased industrialization of the South Carolina Lowcountry, coupled with a rise in cotton prices in the late 1890s, made farming a profitable venture.

In 1901, Quash and his son William purchased their own plantation on Johns Island for $3,000. It could be true that Quash had designs upon buying land on Kiawah, and the plans fell through. So he bought land nearby, on the Stono River. Quash's new place was called Seven Oaks, and it contained 839 acres. The plantation even had a country store on it. Quash continued to diversify his ventures on Seven Oaks, selling the timber rights on his plantation for $1,000. In November 1909, Quash and William Stevens sold their land for $3,500. Four months later, on March 20, 1910, Quash Stevens died of heart failure and was buried on Johns Island.

What about the rest of the African Americans who lived and worked on Kiawah Island in the early twentieth century? In 1900, there were twelve black households on the island, containing seventy-nine people. Harry Gregg and his wife Cindy, age seventy-five years, were the oldest people on Kiawah. The elderly couple was raising their twin grandchildren, Daniel and Carrie. The youngest person was ten-month-old Robe Preston. Robe had two sisters and a brother. There were thirty-one children younger than eighteen years old on Kiawah, so the strong African American heritage on the Sea Islands continued.

Most of the adults had been born slaves. Only seven adults were younger than thirty-five years old in 1900. That condition undoubtedly influenced the blacks' decisions about where they would live and how they would eke out a living. It is likely that most, if not all, of the adults had been slaves on Kiawah before emancipation. Another interesting fact to cull from the records is that two households in 1900 had boarders. Seventeen-year-old Charlie Irvan was a boarder in Simon Boggs's household, while Smart Strobart had three boarders in his house, Maria Gibbs and Sarah and Mary Mitchell. Maria Gibbs was thirty years old and the Mitchell girls may have been related to Maria. It is possible that the single, older woman was responsible for raising the Mitchell girls, and in order to make ends meet they may have moved to Kiawah and joined the Strobarts. It is also clear that women were working in the fields next to the men. The census taker of 1900 also recorded that most of the blacks living on Kiawah were literate. The records reveal that only a handful of the seventy-nine blacks were unable to read and write. There are references in the Vanderhorst papers about a county-supported school that ran on Kiawah. The school had only one teacher, yet the Kiawah community learned how to read, write and to understand elementary arithmetic. The Kiawah school closed around 1909, probably because it was difficult to hire a teacher. Arnoldus Vanderhorst V wrote to an official with the Charleston

County Schools in December 1910 and lobbied to have the school reopened. Vanderhorst noted that the blacks on Kiawah wanted to be educated, and "if the school were allowed to lapse entirely, it would undoubtedly become a cause of dissatisfaction and result in driving people" from Kiawah. The adults on Kiawah wanted to keep the school not for their children's benefit, but for their own. An education official noted, "Many that attended last season were men and women, not children at all."

Ten years later, the profile of the African American community on Kiawah Island revealed the changing nature of life on the Sea Island. The number of blacks on Kiawah dipped a bit, down to seventy-four people. The number of households increased to nineteen. The oldest person was seventy-year-old Hagar Gray, who lived by herself. But overall, the population on Kiawah got younger. The number of boarders went up dramatically. There were twenty listed in 1910; the youngest boarder was sixteen, the oldest was forty years old. Only three members of this community were old enough to have been born into slavery.

In 1893 John and Amelia Haile's only child, James, died without any children. As a result of the marriage settlement the portion of Kiawah Island that Amelia had inherited reverted back to her father's estate's ownership. During the first decade of the twentieth century, Adele Allston Vanderhorst became the sole owner of Kiawah Island. She bought the Haile tract in 1900 for $3,500. For the first time since the 1770s, one person owned the entire island. The generation born after the Civil War shunned the plantations. Agriculture stopped being a career choice for bright young Southern men. Most chose to live in the cities and run a business, practice law or work at a bank. Throughout the South, plantations were sold and the proceeds scattered amongst the heirs. Adele and Arnoldus Vanderhorst IV had seven children. The daughters were Adele, Anna, Frances and Elizabeth. The three sons were Elias, Arnoldus V and Robert. The African Americans working on Kiawah continued working hard on the island, but they rarely reaped any rewards for their efforts. They had a place to live, but constantly struggled to earn a meager living. After Quash Stevens left Kiawah in 1901, the situation became more difficult. Adele's son, Arnoldus V, helped his mother manage the island. A recent graduate of the University of Virginia's law school, Arnoldus would be intimately involved with Kiawah Island until his death in 1943.

In early 1901, Arnoldus V attempted to bring some stability to the situation on Kiawah. He allowed each of the black families seven acres of planting land, at a renting fee of twenty dollars for the year. The Vanderhorsts also supplied the housing on the island and the black families supplied the labor to produce the crops. Another concern after Quash's departure was the poor condition of the bridge and causeway that connected Kiawah and Seabrook Islands. Arnoldus wrote in the spring of 1901 that the bridge was in constant use, and it was a "menace to life and property." The bridge was repaired, for a few years later Arnoldus wrote to an associate, "I would not have you think that this island is cut off. By crossing a small river we reach a post office."

The most interesting trend that emerged after can be seen in a letter written by Arnoldus in January 1901. He wrote to a man named Jason Hanahan, "any proposition to make, for the purchase of the property, will be considered." If Hanahan made an offer it didn't survive, but Adele Vanderhorst considered selling Kiawah after Quash left. The suggestions to sell Kiawah would get stronger as the island struggled in the early twentieth century.

Beginning in early 1902, W.R. Jenkins, formerly of James Island, managed Kiawah Island for the Vanderhorsts. In late January Arnoldus came to the island "to look over the labor situation, and conclude definitely about cotton acreage." Apparently Jenkins's tenure on Kiawah was not productive. In December 1903, Vanderhorst wrote to Jenkins, "I was at Kiawah yesterday and disappointed to find you absent. The present state of affairs there is not satisfactory." A.B. Wescott replaced Jenkins as overseer in February 1904.

At the time that Wescott started his management of Kiawah plantation he was fifty-five years old. The relationship between Arnoldus and Wescott worked, as the overseer would be associated with the island for the next decade. A letter from late 1904 revealed Arnoldus's respect for the overseer. Vanderhorst wrote, "By planting 100 acres there would be a prospect of both of us really making something. I merely suggest this, for you will have to be the judge."

Wescott experienced success with his first cotton crop. The black laborers grew cotton on thirty-five acres, and harvested a little over 9,600 pounds of sea-island cotton. Arnoldus commented that the "crop this year is unusually large." They sold the cotton at twenty-seven cents per pound, while Wescott and Vanderhorst's profit was a dime per pound. Arnoldus seemed a little frustrated. He wrote to Wescott, "From information that I have the market seems to be on the decline and there is so much sea-island cotton in the warehouses awaiting a buyer." For the next year's harvest, Arnoldus wanted more acres planted in cotton, and he wanted to attract more laborers to Kiawah. In 1905, the black laborers planted fifty-six acres of sea-island cotton, which produced 13,718 pounds. Vanderhorst and Wescott's profit was eleven and a half cents per pound.

Arnoldus Vanderhorst began to articulate difficulties with Kiawah cotton production during the harvest season of 1906. He described Kiawah plantation: "Operations are confined to sea-island cotton and livestock, and I am now trying to cast around for practical ideas along the line of a fruit orchard, also poultry raising." Vanderhorst seemed anxious about overproduction of cotton, and he was also concerned that it was becoming more difficult to secure labor on Kiawah. Overseer Wescott wrote him in November, excited about the amount of cotton produced, "about 21 or 22,300 pound bales." Yet "he had a hard time getting it picked from lack of labor." Arnoldus wrote to Wescott a few days later, stating that "the cotton ought not to bring less than 35 cents [per pound], but it will probably be a fight to sell." The Kiawah sea-island cotton crop of 1906 measured 6,221 pounds. In January 1907, Arnoldus remarked that "it seems to be

a short crop, but that is the case everywhere this year." He urged Wescott to plant more acres of cotton for the coming year.

The sea-island cotton market continued to be unpredictable. For the harvest of 1908, Vanderhorst noted that "the prospect for any sort of price is very poor." In the spring of 1909, Arnoldus Vanderhorst wrote to a few insurance companies, hoping to have his Kiawah cotton crops insured. The companies denied him, yet A.B. Wescott observed that the cotton in the late summer of 1909 was "remarkably fine." For the harvest in 1911 and 1913, hurricanes and dry conditions hindered Kiawah cotton. Vanderhorst and Wescott turned to other ventures to generate income from the plantation.

The largest industry in the New South came to Kiawah Island: lumbering captured the scope of economic change on Kiawah in the first decade of the twentieth century. Arnoldus Vanderhorst II recorded sales of timber off of Kiawah in the late eighteenth century, so the practice was not new. What was new was that a lumber mill was constructed on Kiawah, and a workforce of about twenty African Americans arrived to run it. Beginning in the 1870s the focus of the American lumbering industry shifted from the Great Lakes region to the South. By 1910, Southern production made up 45 percent of the nation's output. Being surrounded by water, Kiawah was blessed with access to markets and ease of transport, but how much quality lumber remained on the island was unknown. Arnoldus Vanderhorst offered F.C. Fishburne the rights to cut timber on the island, but Fishburne turned him down. "I would have much preferred to have purchased outright the body of timber on the island," he wrote Vanderhorst, "but I find the land containing the wood cut up in such narrow strips that it was impossible to make a correct estimate of the timber." A few years later, in the fall of 1910, Arnoldus enticed W.A. Hutchinson about the possibilities on Kiawah, noting the "large quantity of pine to be cut and hauled." Whether or not Hutchinson took him up on the offer is unknown, but Halsey Lumber Company of Charleston had secured about one million feet of logs off of Kiawah by January 1911. Two months later, J.C. Beard and Max Baumrind formed a corporation that harvested oak and pine off the island.

Kiawah's lumber mill was the place of employment for twenty blacks in the spring of 1910. All were male and all were single. It is likely that they all lived together in a barracks on the island. Where this was located is uncertain, as is the location of the mill. What kind of relationship the mill had with the Vanderhorst plantation is unknown, yet the assumption must be that the Vanderhorsts were at least part owners of the mill.

Six of the mill hands were literate. The hands sawed logs and produced turpentine. James Smith, Thomas Smith, Brister Jenkins and Robert Smith, hands who worked in the agricultural fields on Kiawah, were paid six dollars for hauling timber during the summer and fall of 1912. Most the logs on Kiawah were transported to Charleston by raft.

The other economic enterprise that emerged on Kiawah was indirectly related to the lumber industry. Arnoldus Vanderhorst sold the plentiful palmetto fronds on the island. Vanderhorst sold the palms to Catholic churches in early spring for use during the Easter season. This economic activity started about 1900, as the first mention of it

is a February 1902 letter from Vanderhorst citing a "considerable quantity of palms to market." Kiawah produced about ten thousand palm fronds annually. Arnoldus made about eighteen dollars per thousand. Palm cutting occurred early in the year, during the downtime of cotton production. The cutting ended in early March, shortly after planting cotton. This activity generated a few hundred dollars per year, supplementing lumbering and the unpredictable cotton market.

The Vanderhorsts desperately sought to attract interest in Kiawah Island. Arnoldus offered hunting and fishing privileges on the island for $300 per year. He knew from personal experience that Kiawah featured good quantities of quail, duck and deer. Included with the hunting rights was the use of the Vanderhorst mansion, "comfortably furnished." He also sought "a practical cattle man who will develop the business." In 1903 the island had 125 head of cattle, with the potential to have much more. A glimpse of Arnoldus's plans for Kiawah can be seen in a September 1906 letter to his overseer, A.B. Wescott. Arnoldus wanted the black laborers on Kiawah to construct chicken coops. He bought turkeys to be raised on the island and ordered Wescott to plant alfalfa. Arnoldus had some knowledge of what enterprises could succeed on Kiawah. As an attorney and a state legislator (elected in 1906 to the South Carolina House), he was not able to devote all of his energies to the island, and probably did not understand the unpredictability of the daily routine on the island.

In the fall of 1909 Arnoldus articulated his view of conditions on Kiawah. The plantation focused on growing sea-island cotton, with A.B. Wescott in charge of twenty families of black laborers. Arnoldus's desire was to "start another farm if it appears feasible." He sought another man to supervise "a logging contract on the island, prevent trespassing…and devise methods of increasing the revenue from the property, which is a place of fine underdeveloped resources." Arnoldus may have been referring to replanting the old Stanyarne plantation site. His next idea revealed his realization of the difficulty of agriculture of Kiawah Island. Arnoldus proposed to form a club, known as the Kiawah Club, "for the purpose of enjoying and developing the island as a game preserve and place of recreation." This plan would turn the island into a getaway for wealthy white men, getting rid of the black community on Kiawah.

In the early fall of 1910 Arnoldus sent a new labor proposal to some of his hands on Kiawah. He wanted to start planting on the "share system." That is, each family was to plant, cultivate and pick cotton exclusively. Vanderhorst was to advance ten dollars for each acre planted. After the cotton was harvested, it was to be divided equally. A few weeks later, the Kiawah laborers rejected the plan. The laborers probably did not want to confine themselves to cotton and get deep into debt with Vanderhorst.

After the harvest of 1911, A.B. Wescott ended his tenure as overseer on Kiawah Island. The reason why appeared to be obvious, as the plantation produced only three bales of cotton, sold for $188. Wescott and Vanderhorst lost $325 each. The Vanderhorsts replaced Wescott with J.E. Boyer, whose stay on the island was short. Arnoldus wrote to Boyer, "I find certain things done which were never authorized as well as certain articles missing from the house there."

In the spring of 1912, the new overseer on Kiawah was Robert Smith, a black laborer whose family had been working on Kiawah for decades. Arnoldus told him, "I am depending on you to look after things on the island for me and see that no one steals or trespasses. [I] Will pay you for this." Robert lived with his wife and five children. There were nine other farming households on the island in 1912. Apparently there were problems with people trespassing on Kiawah. Arnoldus wrote to the Andell family on Johns Island, "You have been hunting on Kiawah. Do you think it is fair to take advantage of me?" In late 1913, Wilbur Smith, Robert's son, spotted trespassers on the island and he told them to leave. The white men called him a "black son of a bitch" and threatened to shoot him. Robert Smith revealed his anger and frustration to Arnoldus Vanderhorst, writing, "I am taking care of your place and my son most get kill.[sic] That is very hard."

In 1914, people long associated with Kiawah continued to consider possibilities on the island. Adele Vanderhorst's idea was "to form a [hunting] club to take over the place for a term of years." Her son Elias also liked the idea of a hunting club, "where members would build their own cottages and bring their families." A.B. Wescott, who was in his mid-sixties, wanted to "lease the Drayton tract on Kiawah for several years." In November, Wescott went out to the island and "found the buildings in bad shape." Arnoldus agreed, saying the place "has been generally neglected." Robert Smith must have given up his position on Kiawah earlier in the year. Wescott saw an opportunity, but in January 1915, he sustained an injury, forcing him to give up farming on Kiawah. A few months later, on March 15, 1915, Kiawah Island's owner died. Adele Allston Vanderhorst died while visiting family in Aiken, South Carolina. She left behind six heirs and troubled circumstances on Kiawah Island.

8.
SIX VANDERHORST HEIRS
1915–1950

After Adele Allston Vanderhorst's death in 1915, Kiawah Island was owned by her estate, with Arnoldus Vanderhorst V, William Weston and Henry Conner as executors. The six remaining Vanderhorsts were middle-aged, all but one of them was married and hardly any of them would ever agree to each other's ideas about their mother's estate. The will stated that the executors were to "divide and apportion the estate equally per capita among the surviving children." The executors could also "with full authority sell at public or private sale all or any part of my estate." The two major assets of Adele Vanderhorst's estate were Kiawah Island and the house at 28 Chapel Street, in downtown Charleston. How the six Vanderhorst heirs dealt with Adele's estate dominated the conversation about Kiawah Island for the next few decades. The discussion would not always be civil.

A few months after his mother's death, Arnoldus wrote a letter to his brother-in-law William Weston. Arnoldus stated that the main provision of the will was "for the support and maintenance of Frances." Frances Allston Vanderhorst, born in February 1873 and four years older than Arnoldus, apparently had a physical or mental illness. The executors set up a fifty-dollar-per-month allowance to provide for her. In regard to the real estate that his mother owned, Arnoldus concluded that "the Chapel Street property should be sold as soon as possible and the proceeds invested for the benefit of Frances." Yet Kiawah had nothing to do with the ill Vanderhorst sister. Arnoldus's view of Kiawah in the spring of 1915 was: "The place has great potential value, but is at present unproductive, although it can carry itself. I endeavored to make this place productive and for some years was encouraged, but recently the failure of the sea-island cotton market and the lack of means with which to develop along other lines

have cut off revenue. For the present I think this place should be held, at least until there is opportunity for satisfactory sale."

Arnoldus had a desire to maintain the Vanderhorsts' interest in Kiawah Island after his mother died. He would at times send letters to his siblings exhorting them to take pride in their family history and hold onto it. He believed that since the death of their mother, Arnoldus and his siblings should "maintain the family status as far as possible. I regard the heritage as a distinct asset to myself and all members of the family." Arnoldus used these appeals as a way to convince the heirs that they should not sell Kiawah Island. Kiawah was the last major piece of property still owned by the Vanderhorsts, and of course the island also reminded them of the dominance of the planter elite. While the New South continued to embrace industrialization and urbanization, one old South Carolina family tried, with great difficulty, to hang onto an increasingly distant past. Arnoldus often complained to his brother Elias that Kiawah was "rapidly deteriorating" and that he had few resources to improve the situation on the island, yet there is evidence that Arnoldus was making some money from his ventures on Kiawah.

At the beginning of 1916 there were still eight black households living on Kiawah. The blacks attempted to make a living by growing sea-island cotton and cutting palms for Arnoldus Vanderhorst in the late winter and early spring. On January 19, Bohne Brothers, a company based in New York City that sold supplies to Catholic churches, placed an order for twenty thousand large palms and three thousand small ones. Unfortunately, there wasn't much more good news for the island in 1916. In March Arnoldus and his longtime partner, A.B. Wescott, agreed that the possibility of making a profit on cotton was slim, so they didn't plant the staple for the year. Wescott was leasing the western part of the island, the old Stanyarne/Drayton half. Jesse B. Smith began leasing the eastern end of the island, the old Vanderhorst half, that spring. The lease ran for three years, and Smith could graze cattle and cultivate crops. All of the black households on Kiawah owed Arnoldus money for back rent, yet he was not going to press the debts too hard, as he needed the blacks' labor. With all of the problems that Kiawah faced in 1916, there was still a good deal of activity centered on the island. On the lease that Jesse Smith signed there contained a statement at the bottom that said, "This lease is subject to be terminated by the sale of the property herein leased."

Sometime in early 1916 Elias and Arnoldus Vanderhorst concocted a plan. Elias was going to buy Kiawah Island from the estate of his mother, and the proceeds were to go to support their sister Frances. The brothers did not want to sell the island, thereby keeping "Vanderhorst property in the hands of the Vanderhorst." After much discussion among the heirs, Arnoldus and Elias had to reconsider their plans. In October 1916, Arnoldus admitted to Elias that they should "sell either the Chapel Street or Kiawah property just as soon as possible for whatever price is obtainable." He sounded desperate, unaware of the island's market value. Arnoldus had probably never considered a value for the island.

There were interested parties in the fall of 1916 that did put a dollar value upon Kiawah. Arthur Halsey, who ran a lumber company in Charleston, and a partner named Frierson, offered $30,000 to Arnoldus Vanderhorst for the purchase of the island. Arnoldus's response was "that was a small offer for such a large property and they said they could not afford more, and there the matter rests." Arnoldus actually thought that the offer was a bit high, and would have taken the money, but he just did not want to sell the island. Another party came forward in December, assisted by William de Bruyn Kops of Charleston. Arnoldus again issued his contradictory statement, "the property is not now for sale; but I do not mean to say that it could not be bought." Sentimental reasons caused the Vanderhorst brothers to want to hang onto Kiawah, but Arnoldus was generating some income from Kiawah plantation. The island would not be sold in the immediate future.

There was at least one new black household on the island in early 1917: William Freeman and his wife came out to Kiawah. Charlie Scott wrote to Arnoldus about trying to attract more blacks to the island, but he was unsuccessful. During the first few months of the year the black families were primarily involved with cutting palms. The men cut down the palms while the women bundled them together. As the palm cutting ended in March, the blacks planted sea-island cotton. Arnoldus wrote to his overseer Jesse Smith in September to remind the laborers that they owed the owner twenty-five dollars in rent. Arnoldus Vanderhorst wrote to Wilbur Smith, "I want to hear about the rent money of the people on the place." While Arnoldus enjoyed the proceeds of the palm cutting, cotton production and tenancy, his brother-in-law Henry Conner understood that action should be taken with Adele Vanderhorst's estate. Conner, in a February 1917 letter, wrote, "I have heard no plan suggested (except the sale of Kiawah, which has now been abandoned) which could be said to meet the directions of the will and still preserve the Chapel Street house."

World War I caused a boom in cotton production; the years 1917–19 saw the most lucrative sea-island cotton crops ever produced. Using two tons of McCabe's Perfection fertilizer, Kiawah plantation produced several thousand pounds of cotton in 1918. Arnoldus Vanderhorst's plot alone produced 2,500 pounds and was sold at the astonishingly high price of fifty cents per pound. The black households on the island produced cotton as well, so it could be assumed that the laborers had the money to pay their chief creditor, Arnoldus Vanderhorst. Vanderhorst petulantly commented to Johns Island planter and merchant Francis Legare, "According to figures I got from William Freeman the cotton only turned out about 32%. We should do better than this."

The cutting and marketing of Kiawah's palms continued to be profitable as well. Bohne Brothers ordered 25,000 palms from Vanderhorst in early 1918; by March Arnoldus had shipped 17,000. Initially they had agreed upon $18.50 per thousand, but Vanderhorst insisted on a higher price once he shipped the palms. He justified the increase by stating, "We only have the negro labor to depend upon,

and the only way to get anything done at all, is by paying much more money than was customary a few months ago." Bohne Brothers of New York agreed to pay $25 per thousand for the Kiawah palms. Arnoldus's year-end calculations had a profit of $376.30 for the palm cutting. In December 1918, preparing for the next year's contract, he wrote to Bohne Brothers explaining his expectations for 1919: "With the ending of the war labor is a little cheaper…I can now make you a better price." The year that saw the end of World War I was a productive year for the laborers and the owners of Kiawah Island.

In 1919, an interesting arrangement emerged between Arnoldus Vanderhorst and the black families that still lived on Kiawah. In January Arnoldus seemed frustrated with the blacks because they did not want to negotiate with him. Arnoldus sent them a letter, saying to them, "you would rather leave the island than plow one acre for fair pay. Therefore, I am unable to make any arrangement with you for the coming year." The arrangement that the Kiawah blacks eventually made with Vanderhorst was based upon the blacks' participation in palm cutting. On March 24, feeling anxious about filling the order, Arnoldus wrote to Wilbur Smith, one of the blacks on Kiawah. Arnoldus wrote, "I told the people long ago that I must have the palms…I also explained to all these people that it was a condition of being on the place at all."

Cotton grew well on Kiawah in 1919, as Arnoldus's portion produced 2,600 pounds, a bit more than the previous year. Agriculture still enjoyed a boom period, and the activities on Kiawah reflected those trends. In May, Arnoldus reported that "a portion of the island is rented out, and the balance is being planted." Prospects continued to look up, as Arnoldus hired a company to come out to Kiawah and dig test wells for petroleum. They must have been unsuccessful, as there is no further mention of this in the Vanderhorst papers. In spite of brightening prospects, Jesse Smith, who had been renting a portion of Kiawah, let the lease run out and left the island in the spring of 1919. Smith apparently ran a country store on Kiawah, and Arnoldus offered to buy it. W.L. Limehouse leased the eastern end of the island, primarily for the purpose of raising hogs. Arnoldus reported $208.74 collected from Smith and Limehouse for rent in 1919.

While Kiawah was making Arnoldus a nice sum of money, he continued to misrepresent the successes to the other heirs. On April 16, 1919, Arnoldus wrote to his brother Elias that his efforts "to make Kiawah a source of pleasure and profit, is now largely an experiment which may well terminate adversely. In the event that it does I will certainly quit the place." There is no mention of the thousand dollars per year that Arnoldus had been receiving from Kiawah the last few years. He also considered the demise of Kiawah to happen in the very near future. Arnoldus's actions in the next several years showed that he did not believe that the situation on the island was hopeless. He worked hard throughout the 1920s to generate income from Kiawah.

Sea-island cotton production ended on Kiawah during the 1920s. The appearance of the boll weevil, rapidly declining prices and the reduced quality of the cotton itself

were the major factors. In 1920 Sea Island farmers produced only 3,030 bales of cotton. In June 1921, Arnoldus Vanderhorst reported selling a fraction of a bale of cotton. Arnoldus's portion of the 1923 sea-island cotton crop weighed four hundred pounds. With the termination of an old staple, Vanderhorst had to turn to other ways to generate income. The black laborers on Kiawah faced challenges too, as they either left the island or turned to truck farming.

Palm cutting still continued on Kiawah in the early 1920s. Arnoldus really seemed to be irritated, almost trying to sabotage his relationship with Bohne Brothers, the New York firm who bought the palms from him every year. In March 1920 Arnoldus wrote to the company complaining that "I regret having undertaken this order because at the price agreed upon, it does not pay for expense and worry." In the same letter Arnoldus accused Bohne Brothers of paying him an artificially depressed price for the palms. Perhaps out of spite, the company took its time in sending payment to Vanderhorst. On May 20, Arnoldus sent a letter to New York, describing his dealings with Bohne as "unprofitable, but I need the money." He recorded a profit of $763 from the palms. The Kiawah planter upped the price for his palms. In October, he quoted a price of $40 per thousand for the larger palms and $35 per thousand for the smaller palms. Bohne Brothers readily agreed to the deal, ordering twenty thousand for 1921. Palm Sunday fell on March 20, 1921, a much earlier date than usual. Making deadlines and shipments proved to be more difficult, and Bohne Brothers did not think that the palms would be delivered in time, so they tried to cancel their order. On March 1, Arnoldus wrote them a letter, calling their position "flimsy and unreasonable." Arnoldus then threatened his business associates with litigation.

With the de-emphasis upon cotton in the 1920s, the black families living on the island had to adjust. In February 1922, Charlie Scott planted melons, potatoes, cucumbers and cantaloupes. He described the newer look of Kiawah's fields: "the land look[sic] like something to eat." He told Arnoldus that he anticipated making more money truck farming. J.B. Boyer was still on Kiawah in 1922, and he was raising hogs and manufacturing alcohol, which was illegal under Prohibition. In the summer Arnoldus asked Charleston County Sheriff J.M. Poulnot to make "a systemic effort to suppress illegal practices of every kind on the island," particularly "illicit stills." Vanderhorst also alerted federal authorities to the "constant rumors and reports of illicit operations on Kiawah Island."

Tax assessors began to evaluate Kiawah Island differently in the early 1920s. The land was assessed a tax of almost $230 for 1922, yet the county also taxed the buildings on the island as well. Charleston County taxed fourteen buildings on the island at $825. Arnoldus Vanderhorst was beside himself. He fired off a protest to Joseph Hart, county tax assessor, stating that Kiawah "is now almost a wilderness and the buildings, with the exception of one residence, which is not in first class order by any means, are nothing but shanties." Several months later, Vanderhorst claimed, "these buildings no longer exist, and I wish to have the assessment changed." The assessment was lowered, but these

property taxes would rise while the profits from Kiawah continued to drop. Arnoldus would still be complaining to the tax authorities in early 1926, calling the island "an old family property entirely unproductive, and it is already quite a problem to meet the taxes on it for which there is no benefit in return." In 1924, the palm industry continued to do well for Vanderhorst, with new contracts coming in from companies in Ohio and Indiana. In October 1924, Arnoldus wrote to Bohne Brothers that "the demand of palms is strong, but I am reserving 46,000 for you." Yet in a statement of income generated from Kiawah for Adele Vanderhorst's estate, Arnoldus reported only earning $300 from rent from J.B. Boyer.

Dr. William Weston, husband of Elizabeth Vanderhorst, began to make some conclusions about his mother-in-law's estate. He drew up a financial plan so that Frances Vanderhorst could be taken care of by her late mother's estate. If Frances rejected the plan, "the estate will have to be sold for division among 6 heirs. This will of course necessitate selling Kiawah." Frances agreed with the plan, yet the notion of selling Kiawah would get very strong in the middle of the 1920s.

The heirs began to draw battle lines over the estate, especially the sale of Kiawah. Elias and Arnoldus Vanderhorst formed an alliance. Neither man wanted the island to be sold because Kiawah had been owned by their family since the eighteenth century. Elias wrote to Arnoldus in the fall of 1925 broaching the subject. Elias heard that "Folly Island is to be developed by the Citizens & Southern Company," so the "scene has now shifted" regarding Kiawah. Elias proudly wrote, "The imagination is fired and Kiawah is potentially worth millions. From the actual market standpoint it is worth considerably more than it was a year ago." Elias proposed getting at least one of the other heirs to join him and Arnoldus. His brief analysis of his siblings' supposed views on Kiawah are interesting: "I should imagine Adele's [interest in the estate] would be the best, though probably Bessie's could be purchased for money." Elias wanted to acquire another interest in the estate so "in case of any division requiring title one-half of the property at least would rest with us." Elias also wanted to tell any potential buyer that the island was not for sale. He did imagine that a developer would be interested in the island, and if there was a good offer, "we will put the property against the cash for development and profit with the developers proportionally, though perhaps not in equal shares but we will not sell the property." This plan would be tested shortly.

In March 1926, Daniel Sinkler offered the Vanderhorsts $100,000 for the purchase of Kiawah Island. Sinkler certainly had the capital to buy the island, as he owned a real estate and insurance company. After a short consideration, the family refused the offer, believing that they could receive a better price.

Arnoldus's reaction to the Sinkler offer was a plan to divide the island into sixths, and each heir would own roughly 1,800 acres of Kiawah. The other heirs hardly took him seriously and rejected the plan. Yet they all knew that something should be

done to realize money from Adele Allston Vanderhorst's estate. In 1927, all of the heirs were at least fifty years old. Henry Conner wanted to have a deadline of June 1, 1928. Both Kiawah Island and the Vanderhorst house at 28 Chapel Street were to be sold by that date. Henry was clearly tired of the posturing and waiting. The delay was primarily over the value of Kiawah; the heirs thought the longer they held onto the island, the more the value would appreciate. Henry had doubts about these plans, explaining to Arnoldus, "With Myrtle Beach being actively developed and the Cooper River Bridge more or less likely there may be a surplus of beach in this vicinity." Conner guessed that the value of Kiawah was about $150,000–175,000. Arnoldus told Henry that the heirs should "deal primarily with a question of values and not of time." Arnoldus, writing like the lawyer that he was, stated to Conner, "I am weary of the whole affair, but am of the opinion that we should realize on Kiawah in an orderly way by agreement on a price and careful negotiation and not in a way suggested by a worthless guess from you or me as to the duration of anybody's life." Henry responded by saying, "We differ too fundamentally to labour [*sic*] the point or fruitlessly discuss it."

Realizing he was getting nowhere with Arnoldus, Henry Conner turned to his brother-in-law Elias Vanderhorst. Conner repeated his position to Elias, and then stated that the estate should be losing money. He believed that the estate paid high taxes on the Chapel Street house and Kiawah, and neither property brought in much money. Clearly, the properties needed to be sold, but Conner, even though he was a trustee, did not feel entirely comfortable with making the first move. He admitted to Elias that he hoped that "Arnoldus would make the move. He is thoroughly familiar with the whole thing; and it would come far better from him." But Henry Conner still tried to continue the discussions, "fully aware of the criticism I am likely to encounter."

At Christmas 1927, Henry Conner had been speaking with another trustee, Dr. William Weston. Weston married Elizabeth Vanderhorst, and they lived in Columbia, South Carolina. They contacted Trower Cravens, who owned a real estate company in Beaufort. They wanted Cravens to help them identify potential buyers. Conner stipulated that $150,000 would be a figure that the heirs might consider selling for, "But in the case of this island you are dealing with silk, not calico; and it's going to take good money." Privately, to Weston, Henry Conner warned that, "I don't think you can count on either Elias or Arnoldus cooperating—unless it is some very large figure."

By the late 1920s, activities on Kiawah slowed down. Palm cutting continued on the island, yet with black families moving off the island, labor became scarce and expensive. The census of 1930 counted only thirty-one African Americans living on the island. All were farmers. Fifty-seven year old Charlie Scott was the oldest resident, and he and his wife Della were the only people on the island who could read or write. Wilbur Smith, Charlie Snipe and Dilsey Maxwell led the three other households on the island.

In the summer of 1928, two men named Nash and Miller rented a portion of the island. What their activities were remain obscure, though it seems doubtful that they

engaged in any agriculture. M.P Sweatman wrote to Arnoldus in the fall of 1928 that growing anything on Kiawah would be difficult: "As you know it would take considerable work to put the place in A-1 shape for general farming." Nash and Miller may have been conducting another clandestine operation on the island.

In February 1928, Arnoldus presented his ideas on his mother's estate to William Weston. Arnoldus suggested that the Vanderhorst town house, at 28 Chapel Street in downtown Charleston, should be sold as soon as possible. The proceeds from that sale would be distributed among the six heirs. If Kiawah could not be sold, the heirs would split Kiawah into sixths, each controlling a small piece of the island. Arnoldus suggested that the island could be sold for $200,000. He then ended the letter by mentioning that he knew a "New York man who has recently been over the Island. To him I named a price of $300,000. He has just written me from New York that he has interested his associates and is prepared to pursue the matter." No trace of this correspondence survived in Arnoldus's papers, and one must wonder if this exchange actually occurred. One of the South's new "cash crops" during the 1920s and '30s was Northern wealth looking for leisure and investment. Yet Arnoldus knew that he and his brother Elias still controlled the management of the estate.

Realizing that he was not getting many straight answers from Arnoldus, Henry Conner wrote Elias. Conner drew Elias out by saying "the feeling has been created mainly by Arnoldus, not much by you, that he is ever against selling Kiawah." The rest of the heirs wanted to sell the island, and the situation was down to "brass tacks." Elias then repeated his brother's position, a selling price of $300,000, or if no sale, a division of Kiawah into six parts. Elias also knew he was in a strong position, saying to Henry Conner, "After all Kiawah is a Vanderhorst property." And later, "The opportunity should be given to those of the heirs who want to hold through sentiment if for no other reason." There still seemed to be no solution in sight.

The camps had been established. Henry Conner and his wife Anna, William Weston and his wife Elizabeth, and Frances Vanderhorst pitted themselves against Elias, Arnoldus and the eldest sister Adele Vanderhorst. The former group wanted to sell Kiawah, the latter group wanted to keep the property and divide it up. Henry Conner began to question Arnoldus's handling of Kiawah, and wondered how much money Arnoldus was making off the activities on the island. Conner stated, "In the statement of 1926 there was an item of income from Kiawah of $150 and 1927 one of $122 I think; what they came from the statement does not say nor have I the slightest idea." Henry Conner said of Arnoldus and Elias's plan, "I don't know any better method calculated to have the family blow up some more than this." Henry was still bitter a few weeks later. In a letter to Weston, he wrote, "The family which talks so much of family sentiment and family relations is, as to family life, on the rocks; and in my opinion deliberately put there." The dynamics changed a bit in the summer of 1928 when the heirs sold the Vanderhorst town house at 28 Chapel

Street. Only Kiawah remained to liquidate, and the prospects for compromise did not look good.

In August 1928 Weston and Conner engaged another realtor, Wayne Cunningham of Savannah. They obviously hoped that someone would want to buy the barrier island. In late 1928, Henry Conner was weary of the matter, telling Willie Weston that it was "quite a waste of time trying to set Adele, Elias or Arnoldus straight."

From his perspective, Arnoldus Vanderhorst was doing a good job of keeping the other heirs ignorant of his enterprises on Kiawah. The few black farmers on Kiawah planted twenty-five acres during the spring of 1930. A farmer named L.W. Linder rented a portion of the island to raise livestock. The old Vanderhorst mansion still stood on Kiawah, but there were only four other buildings on the island. Living on the island in the 1930s must have been pretty desolate. According to Arnoldus, he only received $25 in rent from tenants in 1930, and Charleston County taxed the island $252.

The concern over the ages of the heirs became very real when Anna Morris Vanderhorst Conner, Henry's wife, died in August 1929 at age sixty-two. Her husband pressed on, determined to settle his mother-in-law's estate. Henry Conner commented to Willie Weston, "Kiawah is possibly already rented. A year ago Arnoldus met me in the street and said he had an offer to rent Kiawah. I never heard a word about it from that day to this." Henry ended this letter to Weston with another interesting thought. Conner hoped to sell Kiawah "before another season comes around. If we don't it will look to be pretty idle to be talking fancy figures for a place no one apparently wants." Prospective buyers probably knew of the difficulty in dealing with Elias and Arnoldus. The asking price (a few hundred thousand dollars) was very high, and the legal niceties might have scared off a lot of potential buyers. Yet one must suppose, like Conner and Weston did, that there were many people who wanted to own Kiawah Island.

As the 1930s began the Vanderhorst heirs aged into their fifties and sixties, yet they still could not agree on how to distribute the estate. In early 1931 Henry Conner reported that he had received an offer for Kiawah of $115,000. Conner immediately turned it down, as he believed the island was worth much more than that. Bernard Baruch, the famous Wall Street financier and South Carolina native, told Willie Weston, "if we could make Kiawah Island a good duck preserve that he would get us more money for it than the Vanderhorst estate had ever possessed." Weston asked Charlie Scott, still living on Kiawah, about the situation and Scott confirmed that there were freshwater ponds on the island. The situation remained the same with the estate. Weston still thought that Arnoldus was unreasonable about Kiawah and Vanderhorst's attitude was as "sole owner of the property." Weston also told Henry Conner that Arnoldus was making money off of Kiawah and not reporting it to the other heirs. In the late summer of 1932, Arnoldus was "having a large quantity of timber cut and selling it and besides this is having many cattle grazing." Weston predicted a "show down" about Kiawah in the near future.

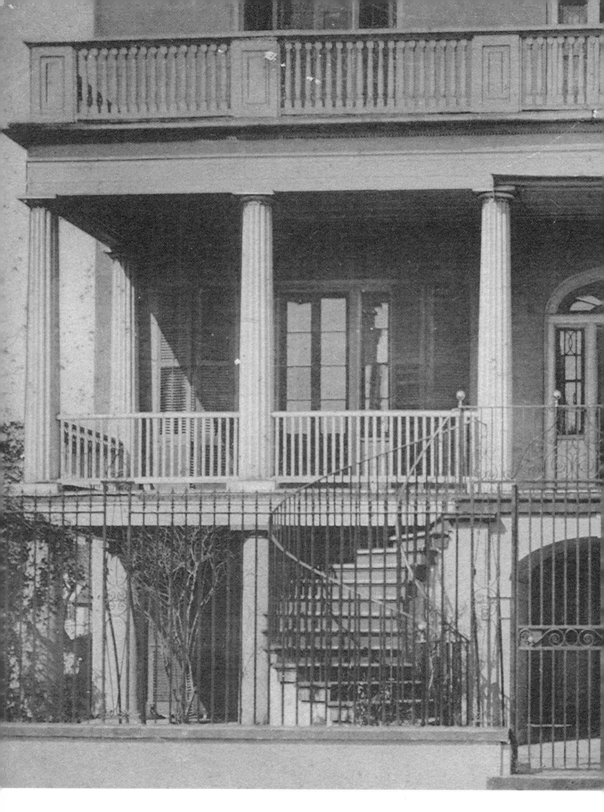

A postcard view of the Vanderhorst house at 28 Chapel Street, Charleston. This is how the house appeared during the late 1920s, when the family sold the house. *Courtesy of the South Carolina Historical Society, Charleston.*

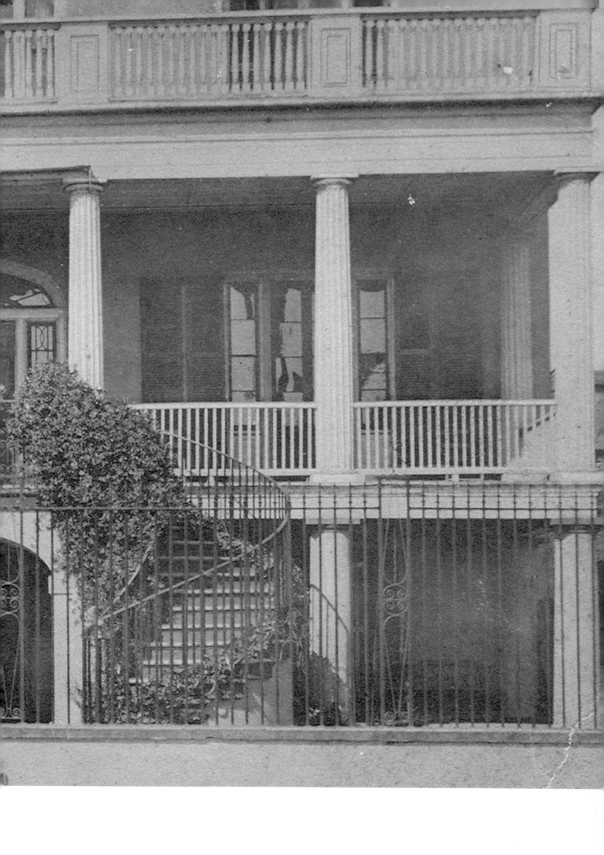

Sometime in the fall of 1933 a man named Hamilton, who lived on Johns Island, approached Arnoldus Vanderhorst about purchasing Kiawah. Vanderhorst rudely told him that the lowest price he would consider would be $1 million. Hamilton concluded that the island just wasn't for sale. The main problem that the heirs faced in trying to sell the island was the uncertainty of the legal situation involving the estate. Clearly there were interested parties, but none of them really wanted to involve themselves in the legal niceties of Adele Vanderhorst's estate. Willie Weston visited the island that fall and discovered large numbers of livestock living on the island. He also saw a fishing camp on the island "where I am informed parties come each week. I am told that there are accommodations for 40 people at one time in this building." Weston emphatically stated to Henry Conner that it was time to settle the estate. Weston wrote, "In case you decide to join with me in proceeding it will probably necessary to employ a lawyer."

By the summer of 1934, Henry Conner and Willie Weston had to concede that the prospects of selling Kiawah in the near future did not look good. The Great Depression had struck the country, and Franklin Roosevelt's New Deal was well underway. Henry Conner surmised that places like Kiawah were "luxuries, and luxuries were the first things to be given up should hard times come." Because of the hard times, Congress set up a series of federal agencies to combat unemployment and starvation. In August 1934, the Federal Emergency Relief Administration (FERA) sent two hundred head of cattle to pasture on Kiawah Island. Shipped from the drought-stricken Midwest, the FERA also shipped cattle to Richland, Newberry and Fairfield Counties. Weston and Conner objected, saying that the cattle were put on the island without proper consent of all of the heirs.

In the middle of the 1930s the Vanderhorst heirs began to be honest about their feelings about the whole situation of the estate. Henry Conner wrote, "I had to give Elias a bit of his own medicine after an inexcusable letter from him; and I gave it to him straight; since then we have had no relations." In 1936, Henry Conner filed suit against Arnoldus Vanderhorst in Charleston County. He dropped the suit a few months later.

On June 16, 1937, Henry Conner received a letter from Adele Vanderhorst Ravenel stating, "I have assigned my interest in Kiawah Island to Elias Vanderhorst." Arnoldus had also turned over his interest in Kiawah to his brother, allowing Elias to have a one-half interest in the island. A week later, on June 23, Elias died in Baltimore at age sixty-eight. A year later, Henry Workman Conner died, never able to resolve Adele Vanderhorst's estate.

In December 1943 Arnoldus Vanderhorst V died. A few months later, Willie Weston filed a petition in the Probate Court, asking for instructions on how to settle the estate of Adele Vanderhorst. The decision came in April 1947. Judge William Grimball decreed that, in the best interests of all of the surviving heirs, Kiawah Island would be sold. The judge ordered that the heirs would accept sealed bids, to be opened at a time fixed by

Weston. In the meantime, the Kiawah Hunting Club continued to shoot game on the island. A moving company cleaned out the Vanderhorst house in the summer of 1948 and distributed the remaining effects to the family. The Westons both lived long lives. William Weston died in 1962, and his wife Elizabeth Vanderhorst Weston died in March 1965, at age ninety.

9.

MODERN KIAWAH ISLAND
1950 TO THE PRESENT

C.C. Royal was born on April 30, 1904, in Ambrose, Georgia, a small town in the southern part of the state. During the Depression he became heavily involved in the lumber business. He eventually moved to Augusta, Georgia, and owned a series of lumber companies throughout Georgia and South Carolina. Royal found out about the availability of Kiawah primarily through Harold Seago. Seago operated a lumber mill in Summerville, South Carolina. On November 25, 1950, Judge William Grimball ordered William Weston to sell Kiawah Island to the C.C. Royal Lumber Company. The winning bid was for $125,000.

C.C. Royal's ownership of the island changed Kiawah permanently, as the place was no longer owned by a blue-blooded Charleston family. Instead it was owned by a businessman from Georgia. Royal's wealth and energy modernized the island and allowed his family and friends to become part of the Kiawah story. Royal's first goal was to make the island accessible by car. Begun in the fall of 1952, a causeway and bridge was built to connect Kiawah to the mainland. Electrical lines were also brought onto Kiawah. In the late summer of 1954, C.C. Royal proudly stated that the island was only "35 minutes from Broad Street" by car and an ideal summer home site. The Royal home had already been built on Kiawah, and four other families had bought beachfront homes along Eugenia Avenue, a street named for Mrs. Royal. Development of the small Kiawah community continued in the 1950s. Mrs. Margaret B. Johnson of Augusta, Royal's business manager, acquired the beachfront home at 9 Eugenia Avenue in the summer of 1955 for $25,000. By the late fifties Governor John West, Lieutenant Governor Earle Morris and state Senator T. Allen Legare chipped in to buy a house on Kiawah together. By 1966, there were eighteen vacation homes on Kiawah Island.

Above and right: Two houses along Eugenia Avenue, summer 1956.

Even though the island was still fairly isolated, development on Kiawah did not go unnoticed by the federal government. In July 1959, Senator James E. Murray of Montana proposed legislation in the U.S. Senate that would allow the federal government to acquire Kiawah Island and develop it as a recreation area. C.C. Royal tersely responded, "The island is not for sale." A week later, South Carolina Senator Olin Johnston wrote Senator Murray asking that Kiawah be taken off his bill. The bill died in the Senate anyway. Yet the problem for the Royals did not go away. In early 1961 Senator Clinton Anderson of New Mexico introduced a similar bill. Kiawah's owner responded by saying, "We strongly object to any proposal which would jeopardize our rights as private property owners." This bill, too, died in the Senate.

C.C. Royal died on September 9, 1964. Royal's will set up a series of trusts that held the island. The Royal family assumed full ownership of Kiawah in the summer of 1973. Each of the Royals owned a one-sixth interest in the island. During the last week of July, Ronald Royal publicly stated that the sale of Kiawah was underway. Ronald Royal refused to name the interested party, but he did say that the best use of the island "would be a very high quality development." The official announcement came on February 16, 1974, when Coastal Shores, Incorporated, purchased Kiawah Island from the Royal family. Coastal Shores was a subsidiary of Kuwait Investment Company, which was based out of the Middle Eastern sheikdom of Kuwait. The price tag was $17,385,000. The Kuwaitis' expressed purpose was to develop the island as a resort. As a side note, the Royals retained twenty-one acres of beachfront property on Kiawah.

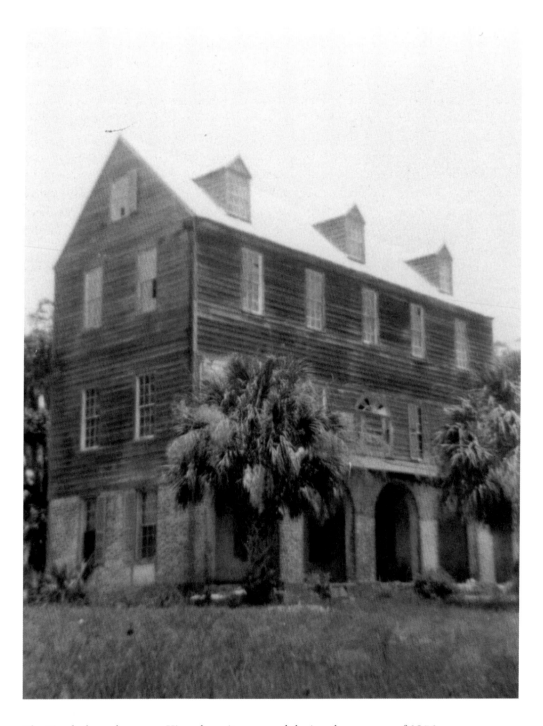

The Vanderhorst house on Kiawah, as it appeared during the summer of 1956.

In order to build their world-class resort, the Kuwaitis contracted the Sea Pines Company. Sea Pines managed the planning and operation of the new resort. Sea Pines had also been one of the prime developers of the Hilton Head Island resort, built several years previously south of Kiawah. Frank Brumley, a vice-president of Sea Pines, outlined plans for the resort in August 1974. Brumley wanted a "resort nucleus" for the prospective purchasers of Kiawah real estate so they could "come, stay and see the island." This nucleus was the Kiawah Island Inn, to open in the spring of 1976. The sale of lots and condominiums would begin when the inn opened. Brumley also emphasized that plans for the island would include public access. "Part of Kiawah will be open to the general public," he was quoted as saying. The Eugenia Avenue development was also mentioned, as Brumley stated that the existing houses would be designed into the overall plan for the resort and the island.

The developers of Kiawah Island encountered some opposition. Local conservationists and the Audubon Society actively opposed development of the barrier island. Frank Brumley of Sea Pines said, "We count ourselves good stewards of the land. We will do a good job. Low profile, low density and good taste are what we are interested in seeing for Kiawah Island." In the fall of 1974 the Audubon Society launched a campaign to have the island designated a National Seashore by Congress. Such a designation would have meant that the federal government would have acquired and preserved Kiawah and made it available for public recreational uses. Yet it did not appear that any politician in South Carolina's delegation to Congress would introduce a bill to the House or Senate. Or, as a newspaper columnist in Charleston asked, "Where would we get the money to buy Kiawah and preserve it?" The conservationists faced many obstacles. Yet the opponents of development on Kiawah continued to fight into 1975. The Kiawah Defense Fund was organized, and the Audubon Society collected thousands of signatures on a petition. These groups also hired a couple of attorneys to see if there were any legal avenues to stop the growth on the island.

The politicians and the money were behind the Kuwaitis and their interests. On January 7, 1975, Charleston County Council approved the development of the resort and new neighborhoods to be built on Kiawah. Most members of Charleston's business community supported the developers, as well as several members of the African American community on Johns Island. Some of the people living on Johns Island thought that Kiawah's success would raise property values and supply jobs. Also, many politicians eyed the potential for tax revenue from a developed Kiawah. U.S. Representative Mendel J. Davis of South Carolina stated publicly that neither he nor anyone else in Washington supported the idea of Kiawah Island being declared a National Seashore. The opposition movement by the conservationists was all but over. Conceding defeat, Ben Gibbs of the Kiawah Defense Fund believed that the county council should "stipulate preservation of important wildlife habitat areas" and impose other restrictions on the developers.

In the spring of 1975 construction continued in earnest on Kiawah. Ten new homes were under construction, and the building of the new Kiawah Island Inn began.

Construction of resort facilities like tennis courts and golf courses were also underway. Further plans were made for the Kiawah resort that fall when Roscoe Tanner signed a three-year contract to serve as director of tennis. The winner of two U.S. Amateur tennis titles, Tanner had been an all-American at Stanford University. When he pledged to work at Kiawah, he was the fourth-ranked tennis player in the country and a member of the Davis Cup team. Kiawah took another step toward becoming a major tennis resort several months later when Roy Barth came to the island as its resident tennis professional. A former UCLA star, Barth played Wimbledon five times and he played eight times in the U.S. Open. Clearly, the new Kiawah Resort had the desire and the backing to be a world-class place.

Just a few more obstacles needed to be taken care of before the official opening of the Kiawah Island Resort in May 1976. The hog population, numbering about 2,500, represented the biggest obstacle. The Kiawah Beach Company had the hogs driven from the island because they were "destructive to the natural environment and the golf course presently under construction." Opponents of Kiawah's development voiced their displeasure, but there was nothing more they could do. The resort continued to prepare for the opening, but an interesting legal problem arose. In early April, the Kuwait Investment Company filed a $1.3-million lawsuit against the Sea Pines Company. The suit alleged that Sea Pines was in default under the terms of its management contract. Kuwait Investment simultaneously severed its management contract with Sea Pines. On April 26, Sea Pines filed a $13.6-million countersuit against the Kuwait Investment Company, charging that the firm had been deprived of compensation in connection with the development of Kiawah. The suits lasted until September 29, 1977, when the companies agreed to an out-of-court settlement. Sea Pines received $500,000 from Kuwait Investment Company. Sea Pines was no longer involved in the management of the Kiawah Resort.

On May 3, 1976, the Kiawah Island Resort opened. The Kiawah Inn featured two swimming pools, two restaurants and a bar. The Charleston Gallery was the more formal dining option at the resort, while the Jasmine Porch was a more casual atmosphere. After dinner, guests migrated up to the Topsider Lounge, where vocalist and pianist Jim Spencer entertained. For forty-five dollars per night, guests could stay in an oceanfront room. Conventions had already started to be planned at the resort. Tennis and golf were the main daytime attractions. The first golf course on the island was not finished until August 1976, yet there was considerable anticipation for it. Legendary golfer Gary Player was the design consultant for the course. The resort's tennis complex contained nine courts, seven clay and two grass, and a clubhouse. Pros Tanner and Barth were there to give lessons. The resort was also building a small shopping center on the island called the Straw Market. The stores included a ladies' boutique, a deli, a beauty shop and a liquor store.

The opening of the Kiawah Resort in May 1976 was an important event in the recent history of the island. Kiawah became accessible to the general public for the first time in

its history. The opening up of the island allowed people to see the beauty and uniqueness of the barrier island landscape, and some people decided to stay. The Kiawah Beach Company began selling real estate in the spring of 1976, and sales went very well. The success exceeded anyone's expectations, running three years ahead of initial predictions. The Kiawah Island Company offered lots, condominiums and three-bedroom cottages for sale. By October, property sales had topped $8 million. Frank Brumley, Kiawah's general manager, said, "We are creating a place where infinite care is being taken not to upset the balance of nature in the pursuit of profit."

There was another opening on Kiawah Island in 1976. On July 6 officials of both the Kiawah Island Company and Charleston County opened Beachwalker Park on the western end of the island. Beachwalker was a public beach, complete with showers, snack bar, parking lot and lifeguards. Charleston County tourism official Ben Boozer described it: "The park is a unique cooperative venture between private enterprise and government." There was no admission fee, although visitors did have to pay to park their car.

In January 1977 the Kiawah Island Company could look back on eight months of successful development of the island. The resort had 70 percent occupancy rates, which exceeded expectations, and real estate sales set records. The developers had sold $12.4 million worth of Kiawah real estate, yet the surprising aspect was that almost two-thirds of the buyers already lived in the Charleston area. Frank Brumley believed that many of these buyers were making Kiawah their primary residence, something that few observers anticipated. Brumley attributed Kiawah's success to its natural beauty, its proximity to Charleston and its "solid financial ownership." In early 1977, a house on the island ranged in price from $60,000 to $150,000. A beachfront house listed at $190,000. The sales momentum continued throughout the year. During the first week of October, fifteen newly constructed oceanfront cottages were sold in one day. A community on Kiawah began to develop, with seventy-six homes on the island. The island boasted an eleven-man fire and security department and a shuttle that carried students to the downtown Charleston private schools.

In the midst of all of this promise there were a few who were disappointed with progress on Kiawah. One of them was the Kuwaiti ambassador to the United Nations, Abdulla Yaccoub Bishara. Bishara cited "great dissatisfaction" in his country with the Kiawah investment. "They think it's a waste of money to invest in this island. Kuwaitis like an investment with easy returns," Bishara claimed. However, the news continued to be good for the island into the late 1970s. In April 1978 Jack Nicklaus announced that he was designing a golf course on the island. The legendary golfer saw great potential in the Sea Island landscape: "The ocean, marsh, ponds and forests will make it possible to make a very good course."

In the later part of the 1970s there was a herd of wild horses that lived on the island. The horses had been on the island since the late 1950s. The herd numbered between fifteen and twenty horses, and they grazed on the golf course and would occasionally frighten

residents and tourists. One of the horses had a deadly disease, equine encephalomyelitis. After that discovery, the horses were rounded up and sold to a slaughterhouse in Walterboro, South Carolina.

The nation's economic picture was not particularly bright in the early 1980s. Inflation climbed above 14 percent. Real estate prices fluctuated, and housing construction declined. Yet these trends did little to affect the development of Kiawah Island. On August 12, 1980, the Kiawah Island Company sold $10.2 million worth of villas and cottages in a new neighborhood called Night Heron Lake. In the summer of 1981 Night Heron Park opened on the island. Covering twenty-one acres, the park featured soccer fields, a playground, a swimming pool and bicycle paths. The Kiawah Island Company continued to build around Night Heron, selling thirty-five two- and three-bedroom villas in a new project called Windswept at an average price of $162,000. In the spring of 1982, Vanderhorst Plantation opened. The new neighborhood was a completely private residential development on the central and eastern portions of the island.

The success for the Kiawah Island Company and its resort continued unabated. In 1983 the company reported sales of $61.5 million and record resort revenues of $22 million. The island featured the Kiawah Island Inn, shops, restaurants, pools, playgrounds, twelve miles of paved bicycle paths, two golf courses and twenty-four tennis courts. The resort employed over a thousand people. In a span of several years, Kiawah Island Resort had become one of the most impressive residential resorts in the nation. Kiawah became widely recognized by wildlife, environmental, travel, sports and recreation groups for the delicate balance between the landscape and progress. There were 364 homes and about 1,100 villas on the island in the fall of 1983. Buyers built houses on the island, obtaining approval from the Kiawah Architectural Review Board. Home prices started at about $170,000. Because of the growth the Kiawah Company built Town Center. Opened in May 1984, the new complex had a conference center and a shopping center.

Yet all was not completely perfect on Kiawah Island during the 1980s. Problems emerged that would plague the community into the twenty-first century. Many island residents and landowners began to question decisions made by the Kiawah Island Company. Many were upset that the company hiked water and sewer rates, sought to manage all rental property on the island and increased fees for company-owned amenities. John Freeman, a law professor and property owner, saw "massive dissatisfaction with Kiawah's management. There is a perception that these people are unfair and that they are overreaching." Senior vice-president of the Kiawah Island Company Charles Daoust replied, "You know what this company wants to do? We want to do some business." The property owners on Kiawah saw the place as a community, while the Kiawah Island Company only wanted to make money. Kiawah also had a crime problem. For instance, between January 1 and May 31, 1986, there were forty-eight cases of burglaries and vandalism on the island. By comparison, there

was one incident on neighboring Seabrook Island. Many Kiawah residents pointed to the island's security force, controlled by the developer. Yet the Kiawah Island Company rebuffed efforts to improve security.

In December 1987, John M. Rivers Jr. signed an agreement to buy the Kiawah Island Resort, the Town Center, the remaining land for development and the Kiawah utility. Rivers had been president of the company that owned WCSC, a television station in Charleston. No purchase price was ever released, but many island residents were pleased with the prospect of new ownership of the island. But for reasons never made public, Rivers declined to buy Kiawah Island Company. Nine days after the Rivers deal fell through, on March 10, 1988, Charleston businessman Charles S. Way Jr. signed a contract to buy Kiawah Island Company and its assets. That summer, Kiawah Resort Associates (KRA), a joint venture group, bought the assets of the Kiawah Island Company for $105 million. Way proudly stated that the sale "returns one of South Carolina's greatest assets, Kiawah Island, from foreign investors to American hands." KRA acquired the Kiawah Resort, three golf courses, tennis facilities, town center, remaining land for development and the Kiawah Island utility. Kiawah Resort Associates consisted of four groups: Seaside Partners, made up of the Long, Way and Darby families; Kiawah Limited Partnership, two firms based out of New York and California; Henry L. Holliday, formerly managing partner of Wild Dunes Resort on the Isle of Palms; and K.I. Management Inc., which was owned by Frank Brumley and Patrick McKinney. Brumley returned to Kiawah to oversee operations.

In the summer of 1988 there were about 250 year-round residents on the island. Most residents feared that the City of Charleston would annex their island. Earlier that year, the South Carolina Supreme Court ruled that cities could annex across bodies of water. Theoretically, the City of Charleston, which had a lot of holdings on Johns Island and Folly Beach, could jump over the Kiawah River and annex the island. Many feared the higher taxes imposed by the City of Charleston. In late August, 426 Kiawah voters overwhelmingly chose incorporation of the Town of Kiawah Island. Voters also elected to have a mayor-council form of government. The mayor would have a two-year term. On December 6, 1988, Kiawah voters elected Edward B. "Bo" Turner, the only candidate, to be the town's first mayor. The first town council consisted of David L. Hott, Lib Melvin, Thomas W. Nelson and Patrick Welch. A month later, the town council produced a budget that estimated revenues of $158,000, including money from taxes, permits and licenses. Expenses included $25,000 for legal advice and $10,000 for construction of an EMS station on Johns Island. Changes also happened on the Kiawah Resort. In 1989, Landmark Land Company paid $35 million to purchase the resort. Kiawah Resort Associates continued to own most of the undeveloped land on the island.

Kiawah's fledgling town government got a severe test in the fall of 1989. In early September Mayor Turner held a strategy meeting on hurricane preparedness. His message was "when we ask you to leave, go."

The next major event that hit Kiawah Island was a group of professional golfers, fans and media. The Ryder Cup golf tournament came to the island in September 1991. The month after the Ryder Cup, the corporation that owned the Kiawah resort, Landmark Land Company, filed for bankruptcy in federal court. The resort continued to attract visitors, yet the ownership question was not settled until the summer of 1993. In July, Virginia Investment Trusts bought the Kiawah Island Resort for $39 million. Beverley W. Armstrong and William H. Goodwin Jr. were the key figures in the company. In regard to the Kiawah purchase, Armstrong said, "We expect people will be very happy with the ownership." Goodwin and Armstrong also owned AMF, the sporting goods company that ran a few hundred bowling alleys across the country. The Virginia company purchased the resort because it was an extension of AMF's business into golf course ownership and its principals were impressed with Kiawah Resort Associates, which still owned the undeveloped real estate on the island. In 1995, Virginia Investment Trusts strengthened its presence on the island by purchasing the Ocean Course for $27 million.

The high travel ratings, international golf tournaments and natural beauty helped Kiawah make its claim as one of the top vacation destinations in the late 1990s. In early 1997, economists from Charleston Southern University concluded that tourists spent $260 million per year on Kiawah and Seabrook Islands. The median price of a house on Kiawah rose 33 percent, to almost $430,000. And for the first time, an undeveloped lot on the island sold for over $2 million. In August 1998, the island's official population finally topped 1,000. The town government estimated its population at 1,400, yet the Census Bureau had a drop in population because of the closing of the Charleston Navy Yard. Kiawah's population did not depend on the base. Mayor Ralph Magnotti also saw some interesting trends in Kiawah's population, stating that "the population is getting younger and the number of children is increasing."

Two of the major issues that the Kiawah town government faced at the beginning of the twenty-first century were problems with no easy solutions. One problem dealt with infrastructure and transportation. In August 2001, Kiawah Mayor Jim Piet urged state officials into looking at finishing the Mark Clark Expressway. Originally proposed in the 1980s, the last leg of the expressway would run from Highway 17 at Citadel Mall to James Island. Officials did not support Piet's desire to complete the expressway, as there was no money for it, and two new bridges were built on Johns Island to alleviate traffic problems.

With the growing permanent population on Kiawah, a major disagreement emerged between full- and part-time island residents. To full-time residents, the vacationers were ruining Kiawah. About 200 of the approximately 1,300 homes on the island were rented out to vacationers each summer. Many Kiawah residents felt that the summer visitors were nuisances. Some property owners put forth a proposal to the town council that would have banned short-term rentals on the island. As the debate proceeded, it became clear that the majority on Kiawah wanted to allow short-term rentals. Charles P. "Buddy"

Darby, managing partner of Kiawah Resort Associates, said that the rental restrictions would be a mistake. To restrict rentals would be to restrict prospective homeowners, resulting in fewer sales and lowering property values. Many of the real estate companies who bought and sold property on the island agreed with Darby. Also, the Kiawah Island Community Association opposed the short-term rental restrictions. As a result of complaints, the association stepped up enforcement of its rental regulations. On April 9, 2002, Kiawah Town Council held a public hearing on the matter. Lasting three hours, thirty people spoke against the rental restrictions and nine spoke in favor. The Kiawah election that fall was dominated by the issue. Voters elected Bill Wert mayor; he supported the short-term rentals. Two of the councilmen elected supported the rental restrictions, yet they conceded that the voters had put the issue to rest. As the baby boom generation retires and moves to areas with warm weather and nice amenities, property values on the island will continue to rise. Yet this issue will probably settle itself. Most of the absentee homeowners will retire and make Kiawah their permanent home by 2010.

In the first decade of the twenty-first century, Kiawah Island is still a beautiful residential and resort community. In August 2004, the Sanctuary opened. The luxury hotel boasts 255 rooms, four bars, three restaurants, a ballroom, 18,000 square feet of meeting space and a huge presidential suite. The island's economic impact on the Lowcountry and the rest of South Carolina is still huge. In 2003, real estate sales totaled $325 million and were responsible for about three thousand jobs. Kiawah Island has 1.2 percent of Charleston County's land base, 2 percent of the households and 0.4 percent of the population, but island property owners pay 11.3 percent of the property taxes. The island has come a long way in three hundred years. An out-of-the-way barrier island when George Raynor acquired it, Kiawah mirrored the development of the South Carolina Lowcountry until the middle of the twentieth century. Now, the island is the fifty-fifth wealthiest town in America, attracting celebrities and the wealthy to its lush, subtropical setting.

Ann Morris Vanderhorst, wife of Elias, shall have the last word. She, like thousands after her, loved Kiawah. Writing in *Cassique of Kiawah* in 1876, Ann wrote a timeless, vivid description of the island. Ann wrote, "the great swath of the island relieves the eye with the sense of freshness and repose, you feel it is the region of beauty and delight."

BIBLIOGRAPHY

Unpublished Primary Sources

Arnoldus Vanderhorst V Family Papers. Charleston: South Carolina Historical Society.

Court of Common Pleas, Judgment Rolls. Columbia: South Carolina Department of Archives and History.

Henry Workman Conner Papers. Charleston: South Carolina Historical Society.

Inventories. Charleston: Charleston County Public Library.

Land Grants, Colonial Series, 57 vols. Charleston: Charleston County Register of Mesne Conveyance, Deed Books.

Land Memorial Books, 1731–1775, 16 vols. Charleston: Charleston County Register of Mesne Conveyance, Deed Books.

Miscellaneous Deeds. Charleston: South Carolina Historical Society.

Miscellaneous Records. Charleston: Charleston County Public Library.

Proprietary Land Grants, 1680–1717, 2 vols. Columbia: South Carolina Department of Archives and History.

Records of the Secretary of the Province, 1671–1743, 44 vols. Columbia: South Carolina Department of Archives and History.

Samuel Catawba Lowry Civil War Diary. Charleston: South Carolina Historical Society.

Transcripts of Records in the British Public Record Office Relating to South Carolina, 1663–1782, 36 vols. Columbia: South Carolina Department of Archives and History.

Wills. Charleston: Charleston County Public Library.

Published Primary Sources

Cheves, Langdon, ed. *The Shaftesbury Papers*. Charleston: Tempus Publishing, 2000.

Cooper, Thomas, and David J. McCord, eds. *The Statutes at Large of South Carolina*. Columbia: A.S. Johnston, 1838–41.

Ewald, Captain Johann. *Diary of the American War*. Translated and edited by Joseph P. Tustin. New Haven, CT: Yale University Press, 1979.

Greene, Nathanael. *The Papers of General Nathanael Greene*. Edited by Dennis M. Conrad and Roger N. Parks. Chapel Hill: University of North Carolina Press, 1976–2004.

Laurens, Henry. *The Papers of Henry Laurens*. Edited by Philip Hamer and George C. Rogers Jr. Columbia: University of South Carolina Press, 1968–99.

"Letters From Col. Lewis Morris to Miss Ann Elliot." *South Carolina Historical and Genealogical Magazine* 40 (1939): 122–36.

Seabrook, Whitemarsh. "On the Variety of Cotton, Proper to Be Cultivated on the Sea Islands." *Southern Agriculturalist*, July 1831: 337–46.

U.S. Department of Commerce, Bureau of the Census.

Webber, Mabel L., ed. "Captain Dunlop's Voyage to the Southward, 1687." *South Carolina Historical and Genealogical Magazine* 30 (1929): 127–33.

Woodmason, Charles. "Method of Raising, Improving and Manufacturing Indigo In Carolina." *Gentlemen's Magazine* 25 (1755): 201–03, 253–58.

Newspapers

Charleston News and Courier.

South Carolina and American General Gazette.

Secondary Sources
Articles

Beeson, Kenneth. "Indigo Production in the Eighteenth Century." *Hispanic American Historical Review* 44 (1964): 214–18.

Carney, Judith, and Richard Porcher. "Geographies of the Past: Rice, Slaves and Technological Transfer in South Carolina." *Southeastern Geographer* 33 (1993): 127–47.

Chaplin, Joyce. "Creating a Cotton South in Georgia and South Carolina, 1760–1815." *Journal of Southern History* 57 (1991): 171–200.

Crowley, John E. "The Importance of Kinship: Testamentary Evidence from South Carolina." *Journal of Interdisciplinary History* 16 (1986): 559–77.

Fox-Genovese, Elizabeth. "Antebellum Southern Households: A New Perspective On A Familiar Question." *Review* 7 (1983): 215–53.

Henretta, James A. "Families and Farms: Mentalité in Pre-Industrial America." *William and Mary Quarterly Third Series* 35 (1978): 3–32.

Jordan, Laylon Wayne. "The Planters of St. Johns Parish (Colleton), 1675–1790." *Proceedings of the South Carolina Historical Association*, 1998: 21–36.

Otto, John S. "The Origins of Cattle-Ranching in Colonial South Carolina." *South Carolina Historical Magazine* 87 (1986): 117–24.

Rosengarten, Theodore. "Passing the Test of Time: Kiawah's Most Venerable Landmark, the Vanderhorst Mansion." *Kiawah Island Legends* 7 (1996): 64–69.

Salmon, Marylynn. "Women and Property in South Carolina: The Evidence from Marriage Settlements, 1730–1830." *William and Mary Quarterly Third Series* 39 (1982): 655–85.

Sharrer, G. Terry. "Indigo in Carolina, 1671–1796." *South Carolina Historical Magazine* 72 (1971): 94–103.

Books

Ackerman, Robert K. *South Carolina Colonial Land Policies.* Columbia: University of South Carolina Press, 1977.

Ayers, Edward. *The Promise of the New South: Life After Reconstruction.* New York: Oxford University Press, 1992.

Bell, Maria Locke. *The Bells and Allied Families.* Columbia: Privately printed, 1953.

Burton, E. Milby. *The Siege of Charleston, 1861–1865.* Columbia: University of South Carolina Press, 1970.

Campbell, William, and John Mark Dean, eds. *Environmental Inventory of Kiawah Island.* Columbia: Environmental Research Center, 1975.

Chaplin, Joyce. *An Anxious Pursuit: Agricultural Innovation and Modernity in the Lower South, 1730–1815.* Chapel Hill: University of North Carolina Press, 1993.

Coclanis, Peter. *The Shadow of a Dream: Economic Life and Death in the South Carolina Lowcountry, 1670–1920.* New York: Oxford University Press, 1989.

Daniel, Pete. *Breaking the Land: The Transformation of Cotton, Tobacco, and Rice Cultures since 1880.* Urbana: University of Illinois Press, 1985.

Hancock, David. *Citizens of the World: London Merchants and the Integration of the British Atlantic Community.* New York: Cambridge University Press, 1995.

Joyner, Charles. *Shared Traditions: Southern History and Folk Culture.* Urbana: University of Illinois Press, 1999.

Leland, John G. *A History of Kiawah Island.* Kiawah Island: Kiawah Island Company, 1977.

Liwack, Leon F. *Trouble in Mind: Black Southerners in the Age of Jim Crow.* New York: Vintage Books, 1998.

McCurry, Stephanie. *Masters of Small Worlds: Yeomen Households, Gender Relations, and the Political Culture of the Antebellum South Carolina Lowcountry.* New York: Oxford University Press, 1995.

Olwell, Robert. *Masters, Slaves, and Subjects: The Culture of Power in the South Carolina Low Country, 1740–1790.* Ithaca, NY: Cornell University Press, 1998.

Pancake, John S. *This Destructive War: The British Campaign in the Carolinas, 1780–1782.* Tuscaloosa: University of Alabama Press, 1985.

Rosengarten, Theodore. *Tombee: Portrait of a Cotton Planter.* New York: William Morrow, 1986.

Trinkley, Michael, ed. *The History and Archaeology of Kiawah Island, Charleston County, South Carolina.* Columbia: Chicora Foundation, 1993.

Waddell, Gene. *The Indians of the South Carolina Lowcountry.* Spartanburg, SC: Reprint Company, 1980.

Woodward, C. Vann. *Origins of the New South, 1877–1913.* Baton Rouge: Louisiana State University Press, 1951.

ABOUT THE AUTHOR

Ashton Cobb received his BA in history from the University of Georgia and his MA in American History from the College of Charleston. He is currently a history instructor at Orangeburg-Calhoun Technical College in Orangeburg, South Carolina.